T0276333

IMAGES
of America

THE LEGACY OF
THE NEW FARMERS
OF AMERICA

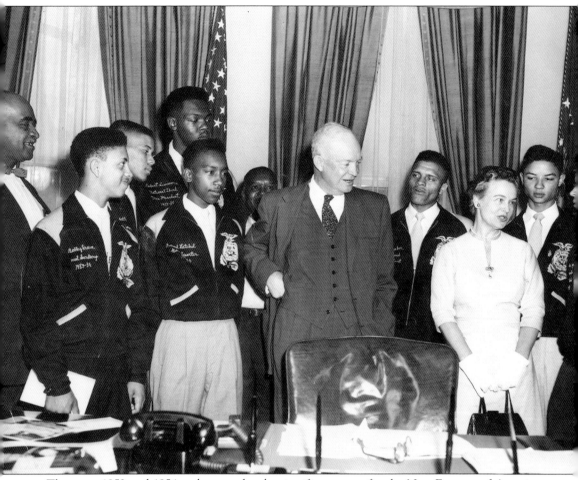

The years 1953 and 1954 truly proved to be significant ones for the New Farmers of America (NFA). In a historic occasion, Pres. Dwight D. Eisenhower greets the 1953–1954 NFA officers in the White House. With the group is Oveta Culp Hobby, secretary of the US Department of Health, Education, and Welfare. (Courtesy of F.D. Bluford Library, North Carolina Agricultural and Technical [A&T] State University.)

ON THE COVER: During the 30-year existence of the New Farmers of America (1935–1965), the College of Agriculture and Environmental Sciences and the Department of Agricultural Education at North Carolina A&T State University served as the headquarters for the organization. Pictured on the cover is the NFA Catawba Chapter standing in front of the Dudley Memorial Building at North Carolina A&T State University during a state convention of the North Carolina Association of the NFA. (Courtesy of F.D. Bluford Library, North Carolina A&T State University.)

IMAGES
of America

THE LEGACY OF THE NEW FARMERS OF AMERICA

Antoine J. Alston, PhD
Dexter B. Wakefield, PhD
Netta S. Cox, MSEd, MLS

ARCADIA
PUBLISHING

Published by Arcadia Publishing
Charleston, South Carolina

Printed in the United States of America

Library of Congress Control Number: 2022930636

For all general information, please contact Arcadia Publishing:
Telephone 843-853-2070
Fax 843-853-0044
E-mail sales@arcadiapublishing.com
For customer service and orders:
Toll-Free 1-888-313-2665

Visit us on the Internet at www.arcadiapublishing.com

This book is dedicated to all former New Farmers of America members and past and current African American farmers. May your light continue to shine.

CONTENTS

ACKNOWLEDGMENTS

This scholarly work would not have been possible without the input and support of many individuals. First and foremost, the authors would like to express their gratitude to Dr. Arthur P. Bell, professor emeritus and chairman emeritus of the Department of Agricultural Education at North Carolina A&T State University, for his meticulous care and cataloging of the New Farmers of America Archives at North Carolina A&T State University for many decades. Without his preservation of this invaluable collection, from which the majority of this work's images originate, this project would not have come to fruition.

Dr. Alston and Dr. Wakefield would like to acknowledge their fathers, the late Albert Alston and the late Freddie Wakefield Sr., who served as their secondary agricultural education teachers and who were members of the New Farmers of America. It is through the foundation and legacy that they provided that Drs. Alston and Wakefield pursued careers in the discipline of agricultural education and in turn have a passion and appreciation for the legacy that was the New Farmers of America and African American agricultural history overall.

Ms. Cox would like to acknowledge her family's continued support and encouragement, and especially her parents, the late Minnie and Daniel Sanders, who instilled in her a belief in God and the importance of education.

Acknowledgement must also be given to Dr. Arwin Smallwood, chairman of the Department of History and Political Science at North Carolina A&T State University, for his historical research expertise and introduction to Arcadia Publishing. Additional thanks must be given to Julie Williams-Warren, who served as the graduate research assistant for this project. Gratitude is also expressed to Dr. Chastity Warren English, professor and coordinator for agriscience education at North Carolina A&T State University, for her edits and encouragement. Other special thanks go to James Stewart, archives and special collections librarian at F.D. Bluford Library at North Carolina A&T State University, for his invaluable contributions. The authors would also like to thank Virginia State University and the Indiana University–Purdue University Indianapolis (IUPUI) University Library for providing key photographs for this project. All images without a credit line are from the F.D. Bluford Library.

Lastly and most importantly, it is the intent of the authors that this publication fully honors and displays the historical significance and legacy of the New Farmers of America and its former members.

INTRODUCTION

NFA Boys are we . . . Happy as can Be. Rolly, Dolly . . . NFA Boys are we.
If you could be with the NFA Boys . . . How happy you would be!

—NFA quartet

This book illuminates the history of the New Farmers of America (NFA), an organization of Black farm boys studying vocational agriculture in the public schools of 18 states in the eastern and southern United States. The authors illustrate the origin and creative expressions of a forgotten history of a prominent Black male student agricultural organization. As readers view this pictorial work, they should take a moment to visualize the voices of the NFA quartets as they competed in local, state, and national events. The words above express the consensus of the body of the organization. In retrospect, "How happy we were" prior to the merger of the New Farmers of America (NFA) and Future Farmers of America (FFA) was the unintentional consequence of the level of quietism expressed by former NFA members. The thought of not having a voice in an organization that provided Black males with dynamic leadership development, responsibility, career exploration, hands-on training, and family structure was unfounded. Yet it became a consequence of the merging of two of the largest male student organizations in America at that time of desegregation.

The authors have often been asked, "Why not interview former NFA members?" The average age of a New Farmers of America member who started as a freshman in high school during the later years of the NFA would be 71 today. His advisor with no years of teaching would be a minimum of 78 years old. The average life expectancy of a Black male is 72.2 years. Moreover, critical information and documents have been lost over the years. Prior to 1998, exactly 33 years after the demise of the organization, no one had taken the initiative to record information from the lived experiences of former members.

To provide readers with an overview of the importance of creating a document of this proportion, one would need to understand what happened in the past that led to the demise of the New Farmers of America and all its history. The National Vocational Education Act of 1917 provided official federal funding for the establishment of secondary vocational agricultural education from which its vocational student organizations, the Future Farmers of America and the New Farmers of America, would evolve. The long-stated goals of the FFA included the development of leadership, cooperation, and citizenship for tomorrow's agriculturalists. It is an educational nonprofit, nonpolitical organization of students designed to develop agricultural leadership, character, thrift, scholarship, cooperation, citizenship, and patriotism. The FFA was open to all races, but due to segregation, most Blacks were not able to become members. For many years, separate schools for Black students were provided in a number of states. It was not until 1964 and the passage of the Civil Rights Act prohibiting segregation in public schools that there were active discussions to merge the two separate organizations.

In 1927, Dr. Walter S. Newman, state supervisor of agricultural education at the State Department of Virginia, and Dr. H.O. Sargent, federal agent for Vocational Agricultural Education for Special Groups (defined at the time as Blacks, Hispanics, and Native Americans), believed that the time was ripe for an organization of Black male agricultural students similar to the Future Farmers of Virginia, the forerunner to the Future Farmers of America. Dr. Sargent in particular believed in the philosophy that young men enrolled in vocational agriculture classes should have the opportunity to develop their social and recreational lives as well as their vocational skills. At his suggestion, Prof. G.W. Owens of Virginia State College, along with Prof. J.R. Thomas, started the New Farmers of Virginia for rural Black male youth enrolled in vocational agricultural education. This organization served as the foundation for the eventual national organization the New Farmers of America.

On August 4, 1935, a special group of Black farm boys and their advisors met at the Tuskegee Institute in Tuskegee, Alabama, with the idea of establishing the New Farmers of America. Seven years prior to this meeting, a small group of White farm boys met on November 20, 1928, in Kansas City, Missouri, for the same purpose, establishing a national organization. They called their organization the Future Farmers of America. The Black group met to create a national organization as well, but the difference was the FFA was nationwide in representation, whereas the Black organization was mainly regional. In August 1935, at the Tuskegee Institute, representatives from all southern state associations met and formed the national organization of the New Farmers of America with a tentative constitution and bylaws. Establishing a national organization was an important step in the development of the NFA. State association members would now be part of a national organization made up of similar groups of agricultural students from other states. One special feature of the NFA's first annual national meeting was the keynote address delivered by Dr. George Washington Carver during the morning session on August 7, 1935. He inspired attendees to render the world with efficient service and explained how they as farm boys were equipped to provide it.

The NFA became a national organization of Black farm boys studying vocational agriculture in the public schools throughout 18 states in the eastern and southern United States from 1927 to 1965. It started with a few chapters and members and concluded in 1965 with more than 1,000 chapters and more than 58,000 active members. The 18 states that made up the NFA were divided into three sections: the Booker T. Washington Section (Delaware, Maryland, North Carolina, South Carolina, New Jersey, Virginia, and West Virginia); the H.O. Sargent Section (Alabama, Florida, Georgia, Kentucky, and Tennessee); and the Almmot Section (Arkansas, Louisiana, Mississippi, Missouri, Oklahoma, and Texas). From 1928 to 1935, all NFA associations were known only by the name of each respective state; for example, NFV for the New Farmers of Virginia. All the other states had similar chapter names.

The purpose of the NFA was to institute and incorporate leadership skills and develop capable rural leaders so students could deal with the future problems of their communities and the people with whom they lived. The national constitution and bylaws of the NFA encouraged its members to:

(1) create more interest in the intelligent choice of farming occupations, (2) assist in the development of individual farming programs and establishment in farming, (3) to strengthen the confidence of the farm boy himself and his work, (4) create and nurture a love of country life, (5) to assist in the improvement of the rural home and its surroundings, (6) encourage cooperative effort among students of vocational agriculture, (7) develop rural leadership, (8) promote thrift, (9) promote scholarship among students of vocational agriculture, (10) encourage recreational and educational activities for students of vocational agriculture, (11) and to advance vocational agricultural education in Black public schools in the states providing such instructions.

The NFA was established on the basis that all students of vocational agriculture in high school were eligible for membership. The organization held an annual national convention, with the

majority of conventions taking place in Atlanta, Georgia. The conventions had various leadership building programs and activities, and many state and national officers attended. NFA awards included H.O. Sargent (Young Farmer Award), Star Superior Farmer, Star Modern Farmer, Dairy Farming, Farm Mechanics, Farm Electrification, Farm and Home Improvement, and Soil and Water Management. There were additional contests in public speaking, quiz, talent, and chorus. There were four types of membership: active (any male student under 21 years of age enrolled in an all-day class in vocational agriculture), associate (any member still active following the termination of active membership status), collegiate (all trainees preparing to teach vocational agriculture and former active NFA members of chartered local chapters enrolled in the institutions concerned), and honorary (any man who helped to advance vocational agriculture and the NFA and who rendered outstanding service to the organization). The four degrees of membership were farm hand, improved farmer, modern farmer, and superior farmer.

To receive the farm hand degree, the member had to be regularly enrolled in an all-day class in vocational agriculture, be familiar with the purposes of the NFA and the local chapter, recite from memory the NFA creed, and receive a majority vote of the members present at a regular meeting of a local chapter.

To receive the improved farmer degree, the individual must have held the farm hand degree and had satisfactory participation in activities of the local chapter, satisfactorily completed at least one year of instruction in vocational agriculture, be familiar with the purposes and programs of work of the state association and national organization, be familiar with the constitution, be familiar with parliamentary procedures, be able to lead a group discussion for 15 minutes, earned and deposited in a bank at least $50, and received a majority vote of the members present.

To receive the modern farmer degree, the individual must have completed at least two years of instruction, be able to lead a group discussion for 20 minutes and pass some occupational or NFA test provided by the state executive committee, earned and deposited at least $200, showed leadership abilities in other organizations, possess a satisfactory scholarship record as certified by the local school superintendent or principal, and participated in an outstanding way in activities for community improvement and the development of agriculture.

To receive the superior farmer degree, each of the three prerequisite degrees must be held. In addition, the individual must have satisfactorily completed at least three school years of instruction in vocational agriculture, must have earned at least $600 from his supervised farming program, shown outstanding ability in leadership and cooperation, and must be recommended by the New Farmers of America National Board of Trustees and receive a majority vote of the delegates present at the national NFA convention.

The NFA emblem included a plow, an owl, the rising sun, an open boll of cotton with two leaves attached at its base, and a bald eagle with shield, arrows, and an olive branch. The emblem also included the letters "NFA" and the words "Vocational Agriculture."

The national officers included a president, three vice presidents (one from each NFA section), a secretary, a treasurer, and a reporter. A local officer team was comprised of the president, represented by the rising sun; the vice president, represented by the plow; the secretary, represented by the cotton boll; the treasurer, represented by the image of Booker T. Washington; the reporter, represented by the US flag and the NFA flag; and an advisor, represented by the owl and an image of H.O. Sargent.

From its inception, the NFA was an organization created to foster the development of citizenship and leadership in its members by encouraging them to share in the fulfillment of their chapter's program of activities, conducting meetings, and serving on committees. Leadership was an imperative skill needed for the success of modern farmers, and it was honed through the unique opportunities for leadership development provided to members of the NFA, including chapter committee work, public speaking, livestock judging, and a plethora of other contests. All activities were conducted under the guidance of the local chapter advisor.

Many Black students participated in the NFA in the South at separate schools, but membership in the FFA was always available to all students enrolled in vocational agriculture where schools

were integrated. In some cases where Black students were enrolled in integrated schools, they enrolled and became members of the FFA. Even though the organizations were separate, the Future Farmers of America Foundation provided all the national awards for outstanding accomplishment by NFA members.

In the early 1960s, the idea of merging the NFA and the FFA was presented to both organizations. It was not until Congress passed the Civil Rights Act of 1964 prohibiting segregation in public schools that all African American students of vocational agriculture could become members of the FFA. After numerous meetings and much skepticism, the merger was approved. Before the NFA–FFA merger, there were many African American teachers, supervisors, and professors. A decade after the Smith-Hughes Act in 1917, African Americans in these professional fields increased rapidly. After the federally mandated desegregation and state compliance efforts of the 1960s ended, the infrastructure that maintained substantial numbers of African Americans in agriculture declined drastically. Between 1917 and 1935, the agricultural education profession saw a rapid increase in the number of Black agricultural teachers, yet after desegregation in the 1960s, there was a major decline. With the decline in African Americans in key roles, membership in the agricultural sciences has steadily decreased for African Americans in agriculture.

Many of the goals of the New Farmers of America were the same as the Future Farmers of America. The NFA and the FFA met in 1962 to consider merging. The process took time and was very difficult due to some of the states being reluctant to follow the pressures of the government. It was not until the federal government threatened to withhold dollars from the organizations that states come on board. The White House, Secretary Anthony Celebrezze, and Commissioner Francis Keppel indicated their dissatisfaction with the progress that was being made toward integrating the organizations as early as 1963. A similar situation was taking place at the same time within home economics and the Future Homemakers of America (FHA), which was for white females enrolled in home economics at the secondary level, and the New Homemakers of America (NHA), which was for Black females enrolled in home economics at the secondary level. The need for merging the four student organizations (the FFA, NFA, FHA, and NHA) was discussed by national board members of all the organizations, and they all agreed it was inevitable for both agricultural education and home economics. Regarding the NFA and FFA, in 1965 the merging began, with only one side seeming to have lost its identity, while the other side lost none. The NFA was required to give up its name, constitution, bylaws, emblems, money, and all its members to the FFA, which gave up nothing. The Black teachers and state staff who had previously taught about the NFA were now required to teach about the FFA and arrange for the disposal of all NFA items. The overlooked element of this agreement was the fact that there was a discussion to dispose of all NFA items. Many individuals at the time of the merger thought it was a good idea, but others did not, especially with everything that was taking place after the Civil Rights Act. There was a common belief that desegregation ended the infrastructure to sustain Blacks in agriculture. Blacks were apprehensive of being merged out of rather than merged into roles of usefulness and effectiveness, and in addition, they had never been represented by employment in professional positions in agricultural education at the federal level.

The authors use the word "merge" loosely, because history has shown that this was not a merger but an absorption. The disadvantages of merging organizations are often due to culture clashes and consumer dissatisfaction. According to the website WallStreetMojo, a merger can be said to be successful "when the strategy of the management is strong enough and clear in order to ensure that there is synergy benefits for all involved in the process." In less than 35 years, much of the history, archival information, and artifacts of the New Farmers of America was destroyed, displaced, or spread out over the nation. This book reveals the long-awaited history of the New Farmers of America, the once thriving student vocational organization of Black males in agriculture in America.

HIStory!!

One

SEEDS OF THE COTTON BOLL

In 1896, the US Supreme Court, through *Plessy v. Ferguson*, established the "separate but equal" doctrine that would dictate the structure of public school education in the southern United States until the 1950s. It was under the auspices of this doctrine and the National Vocational Act of 1917 that the seeds of the organization of the "cotton boll," the New Farmers of America, was established. Throughout the history of the southern United States, cotton served as the primary commodity undergirding the economic foundation of the agricultural industrial enterprise and thus served as the recognized centerpiece of the NFA emblem.

Interestingly, unlike most organizations that start with a national governing body and then form state and local affiliates, the NFA did the opposite. Its roots were formed at Virginia State University in May 1927 with the New Farmers of Virginia under the direction of Prof. G.W. Owens, head teacher trainer in agricultural education, at the suggestion of Dr. H.O. Sargent, first federal agent for vocational agricultural education for special groups. From there, other state associations formed, and in 1929, at the Orangeburg meeting of the Booker T. Washington Section, the consensus of opinion of representatives was that a national organization was not only feasible, but highly desirable. A committee was appointed to submit recommendations at the next sectional meetings for the organization and also to design appropriate pins, medals, and keys. S.B. Simmons (agricultural teacher educator, North Carolina A&T State University; state NFA advisor, 1935–1957; national executive secretary, 1935–1941; and executive treasurer, 1935–1955) chaired the committee and provided leadership to form organizational symbols and structure. The colors chosen by the committee were black and old gold, which were used for all official dress and functions.

The first national meeting of the NFA took place at the Tuskegee Institute on August 4–7, 1935. The organization's tentative constitution and bylaws were formally adopted in 1936 at the second national convention at the Hampton Institute in Hampton, Virginia. Beginning in 1949, all national conventions took place in Atlanta, Georgia, until the merger with the Future Farmers of America in 1965.

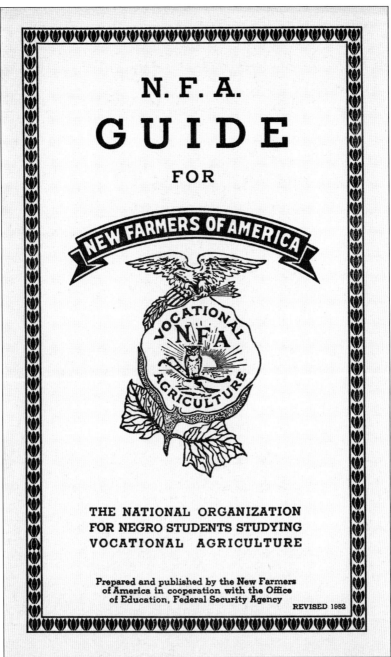

At the heart of the New Farmers of America's operational structure was the *NFA Guide*, a publication of the US Office of Education, Agricultural Education Branch, and its symbolic and widely recognized emblem. In this photograph, the 1952 *NFA Guide* is displayed. Contained within the guide were key items such as the NFA's constitution, creed, organizational history, ceremonies, and many others. At the center of the cover is the NFA emblem, comprised of the plow representing tillage of the soil, the owl representing wisdom, the rising sun representing progress, an open boll of cotton representing important economic agricultural interests of many members, and an eagle representing the national scope of the organization.

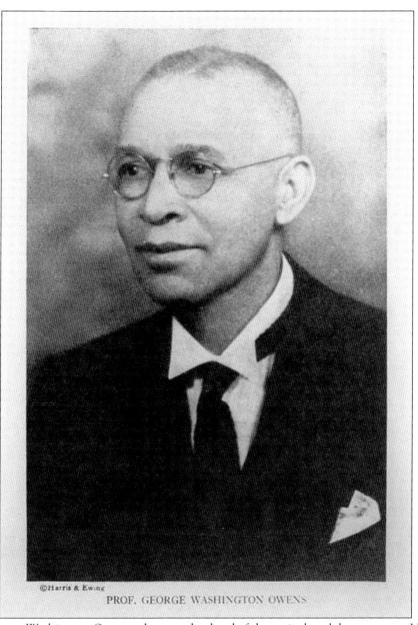

©Harris & Ewing

PROF. GEORGE WASHINGTON OWENS

Prof. George Washington Owens, who served as head of the agricultural department at Virginia Normal and Industrial Institute, later known as Virginia State College and then Virginia State University, was a key figure in the founding of the New Farmers of America. With the encouragement of Dr. H.O. Sargent, federal agent for vocational agricultural education for special groups, Owens founded the New Farmers of Virginia in 1927. The NFV became the basis upon which other similar state associations were founded, eventually collectively becoming the national organization of the NFA in 1935. Professor Owens wrote the foundational constitution and bylaws for the organization. He was reared on a Kansas livestock farm and graduated from Kansas State Agricultural College in 1899 as its first Black graduate. Dr. Booker T. Washington employed him as an assistant to Dr. George Washington Carver, and he was head of the dairy department at the Tuskegee Institute from 1899 to 1908. (Courtesy of Virginia State University Library.)

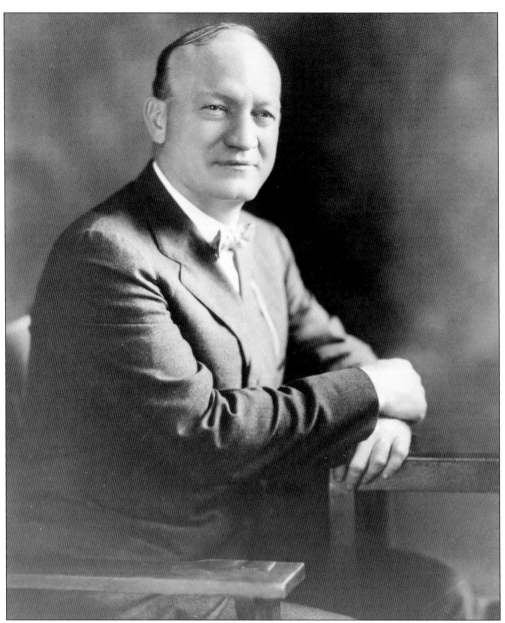

Dr. Harvey Owen Sargent was born in 1875 and reared on a farm near Russellville, Alabama. He graduated from the Alabama Polytechnic Institute at Auburn with a bachelor's degree in agriculture in 1901, where he also received a master of science degree. He later earned both a master of arts and PhD in 1907 from George Washington University in Washington, DC. In 1917, Dr. Sargent was appointed by the US Office of Education as federal agent for vocational agricultural education for special groups, where he was placed in charge of vocational training in agriculture for Black schools. The NFA was started at the recommendation of Dr. Sargent, who firmly believed that the time was ripe for an organization of Black agricultural students similar to the Future Farmers of America. Dr. Sargent made arrangements for the first meeting of the NFA in August 1935. He was injured in an automobile accident near Baton Rouge, Louisiana, on February 3, 1936, and died from his injuries on February 12. (Courtesy of IUPUI.)

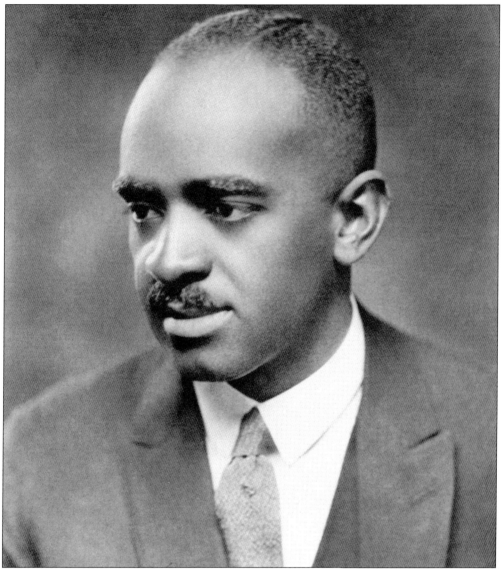

Sidney Britten Simmons (1894–1957) was born in Mecklenburg County, North Carolina, and attended Lincoln Academy in Kings Mountain, North Carolina, and Fayetteville State Normal School. He matriculated with degrees in agricultural education from both North Carolina A&T State University and the University of Illinois, with further studies at the University of California, Kansas State College, and Colorado State University. He went on to teach vocational agriculture at the Dowingtown Industrial School in Pennsylvania and the Topeka Industrial School in Topeka, Kansas. He also served as teacher-trainer for vocational agriculture at the Tuskegee Institute, itinerant teacher-trainer at North Carolina A&T State University from 1924 to 1930, and assistant supervisor for agricultural education in Black schools from 1930 to 1957. He was instrumental in founding the North Carolina Association of the New Farmers of America and was a central figure in the development of the national organization, serving as the executive secretary-treasurer from 1935 to 1941 and executive treasurer from 1941 to 1955. He was honored by both President Roosevelt and President Truman with certificates and medals for his work with the Selective Service during World War II.

CREED

OF

THE NEW FARMERS OF AMERICA

I believe in the dignity of farm work and that I shall prosper in proportion as I learn to put knowledge and skill into the occupations of farming.

I believe that the farm boy who learns to produce better crops and better livestock; who learns to improve and beautify his home surroundings will find joy and success in meeting the challenging situations as they arise in his daily living.

I believe that rural organizations should develop their leaders from within; that the boys in the rural communities should look forward to positions of leadership in the civic, social and public life surrounding them.

I believe that the life of service is the life that counts; that happiness endures to mankind when it comes from having helped lift the burdens of others.

I believe in the practice of cooperation in agriculture; that it will aid in bringing to the man lowest down a wealth of giving as well as receiving.

I believe that each farm boy bears the responsibility for finding and developing his talents to the end that the life of his people may thereby be enriched so that happiness and contentment will come to all.

The NFA creed served as the foundational statement of the organization's beliefs for all student members. Adapted from the *Country Boy's Creed* written by Edwin Osgood Grover, it consisted of six stanzas outlining six beliefs that all members were expected to recite and exemplify in their daily lives. The first belief related to the dignity of farm work. The second concerned a belief in the production of better farm commodities and home beautification. The third and fourth stanzas emphasized the development of rural leadership and a life of service. The fifth centered on cooperation in agriculture. The last emphasized that farm boys have a responsibility to develop their talents for the enrichment of their communities.

The official NFA jacket is made of durable 12-oz. water-repellent vat-dyed black corduroy and has a concealed zipper fastener, slash pockets and adjustable waist. Swiss embroidered NFA emblems, in full color, are sewed on front and back:

Lettering has been standardized nationally and only the following is permitted:

Back Lettering: State above the emblem and Chapter name below the emblem completely spelled out.

Front Lettering: Full name or nickname (not both), *one* office and date.

Item N-1-A Corduroy Jacket, Complete $8.75

IMPORTANT: Please give chest size when ordering from the following sizing chart. Be sure the correct size is ordered! Once a jacket is lettered it cannot be exchanged.

Chest sizes:

30 | 32 | 34 | 36 | 38 | 40 | 42 | 44 | 46 | 48 | 50

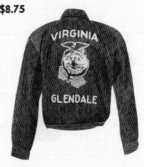

1

The official NFA jacket served as the core of the organization's official dress. Made of durable 12-ounce, water-repellent, vat-dyed black corduroy, the jacket was a recognized symbol of the organization. The back of each jacket consisted of the student's home state in all capital letters at the top, with the NFA emblem in the middle and their chapter name below. The front of the jacket included the NFA emblem on the left and the student's name and office, if applicable, on the right. The jackets could easily be identified by the organization's official colors of black and old gold.

Vocational Agriculture

Chicken Raising

S. B. Simmons, supervisor of Vocational Agriculture, shown paying a regular visit to one of the chicken farmers. He is inspecting one of the high producing flocks for war production purposes.

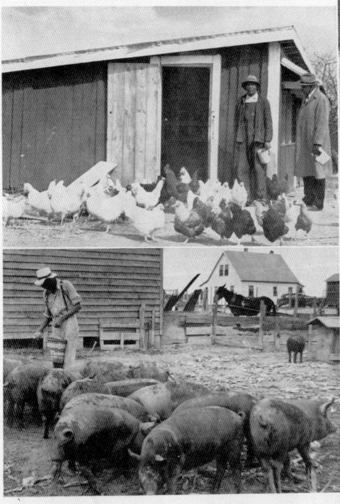

Swine Production

Bertie county farmer goes all out in helping his county meet its swine production quota for the year. Professor Golden Roland is agricultural director in this section.

Operates Machinery

Farmer shown (center) operating one of the three units of farm machinery recently purchased cooperatively in Halifax county. The effort was sponsored by Professor W. B. Jamison.

The vocational agriculture program, which included the NFA as a major component, was an integral part of the rural community for both students and their families, particularly in rural Black communities. At top left, S.B. Simmons inspects a high-producing flock for war production during the World War II era. At bottom left, a Bertie County, North Carolina, farmer who received technical assistance from Prof. W.B. Jamison at North Carolina A&T State University is shown with his swine herd. At top center is a ham show for one NFA chapter. At center, a Halifax

Vocational Agriculture

New Farmers of America
Ham Show of N. F. A. members at one of their regular meetings.

Egg Incubator
Receiving instructions in latest technique of grading eggs.

Cannery
Products (shown left) are taken from one of the twenty-three canneries of North Carolina which are supervised by Negro Vocational Agricultural teachers.

Bean Production
Tenant farmers in Edgecombe County prove that tenancy is no barrier to the production of food for the home.

County, North Carolina, farmer advised and sponsored by Prof. W.B. Jamison operates one of the three units of farm machinery purchased cooperatively. At bottom center are products from one of the 23 canneries in North Carolina supervised by Black vocational agricultural teachers. At top right, students receive instruction on the latest techniques of grading eggs. At bottom right, tenant farmers from Edgecombe County, North Carolina, harvest beans for the home.

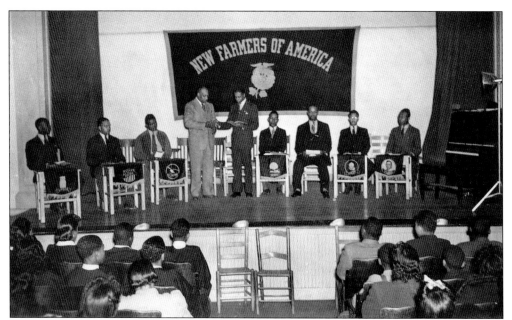

James W. Warren, a former NFA national president, confers the honorary superior degree on Dr. Glenn T. Settle, director of *Wings Over Jordan*, which made broadcast history as the first independently produced national and international radio program created by African Americans. The NFA was able to acquaint large numbers of people with its program by having four of its adult officers speak on the program about Booker T. Washington and the NFA. Also in this photograph are the NFA officer banners, from left to right, the owl (advisor), the reporter (US flag), the vice president (plow), the president (rising sun), the cotton boll (secretary), and Booker T. Washington (treasurer).

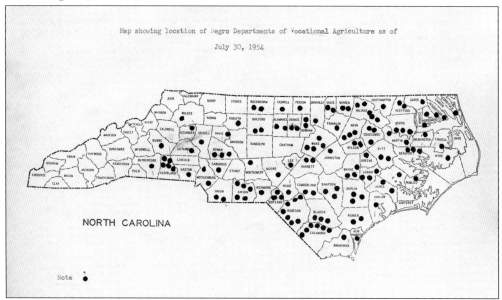

The North Carolina Association of the NFA consisted of several chapters across the state. This map displays all "Negro Departments of Vocational Agriculture" that existed as of July 30, 1954, in North Carolina.

Two

COTTON BOLL LEADERSHIP

As with any organization, strong leadership is the key to its success, and organizing the "Cotton Boll" was no different. As mandated by the NFA constitution, the organizational leadership consisted of both student officers and adult officers. At the national level, the student officers consisted of a president, three vice presidents (one from each NFA section), a secretary, a treasurer, and a reporter. The adult officers consisted of an administrative advisor, an advisor, three sectional advisors (one from each NFA section), an administrative executive secretary, an executive secretary, and an executive treasurer.

Interestingly, instead of letting one of the Black adult NFA state advisors—who were more than qualified from both an education and experience perspective—serve as the administrative advisor, the chief of the Agricultural Education Service of the US Office of Education, who was White, was given this appointment. Moreover, the chief had the authority to designate a member of his staff as the administrative executive secretary, who was also White, thus creating a national leadership structure for Blacks with White control, which promoted a paternalistic atmosphere with an implied message that Black agricultural professionals were not qualified to lead an organization founded for their race, furthering the "separate but equal" doctrine. This situation created by the US Office of Education forced the NFA to become legalized under the Agricultural Education Service, consequently eliminating the autonomy of the New Farmers of America and its Black leadership.

The NFA board of trustees, which held full administrative authority of the organization, consisted of the national student officers, administrative advisor, advisor, administrative executive secretary, executive secretary, executive treasurer, and outgoing national president.

For the state associations, the leadership structure consisted of a president, vice presidents, secretary, treasurer, reporter, administrative advisor (state supervisor), and advisor (appointed from the agricultural education staff by the state supervisor). Lastly, at the local level, the chapter officers consisted of a president, vice president, secretary, treasurer, reporter, and advisor (local teacher of vocational agriculture). Other officers could be added as desired.

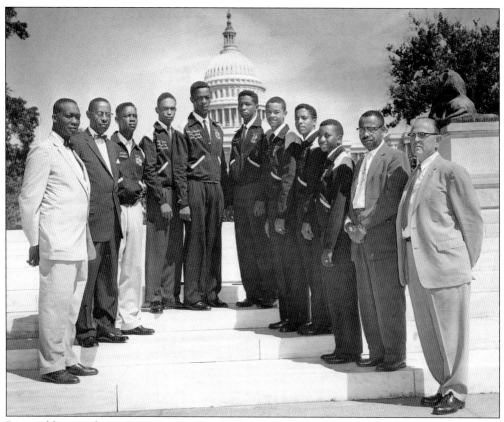

Pictured here is the 1956–1957 NFA national student officer team along with its adult officers. The student officers represented Alabama, Virginia, Georgia, Louisiana, South Carolina, Texas, and Tennessee. The adult officers in the photograph are G.W. Conoly (far left), national NFA adviser; E.M. Norris (second from left), NFA executive secretary; W.T. Johnson (second from right), national executive treasurer; and W.N. Elam (far right), national administrative secretary.

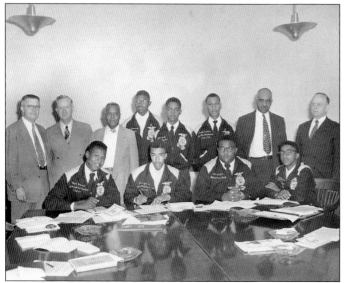

The 1952–1953 NFA board of trustees was comprised of five adult officers, including administrative advisor W.T. Spanton (standing, far left), administrative executive secretary W.N. Elam (standing, far right), and executive treasurer S.B. Simmons (standing, second from right), and seven student officers from Kentucky, Louisiana, North Carolina, Texas, Georgia, West Virginia, and Mississippi.

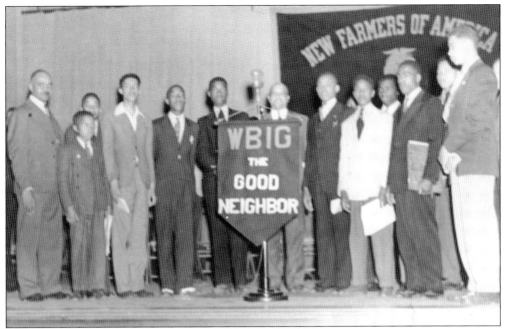

The North Carolina Association of the NFA observed Booker T. Washington's birthday (April 5) on April 9, 1942, with a statewide program that was broadcast over stations WBIG in Greensboro and WPTF in Raleigh. The program took place in the Richard B. Harrison Auditorium at North Carolina A&T State University.

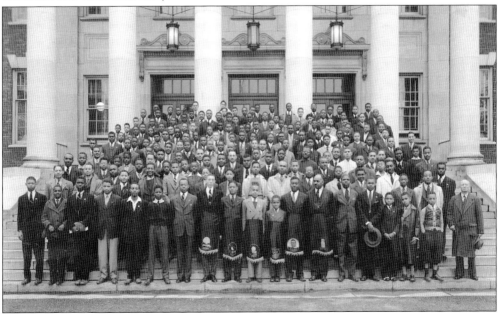

This photograph shows a meeting of the North Carolina Association around the 1940s. In the middle of the first row, five NFA student members wear officer aprons along with advisor S.B. Simmons (first row, seventh from right). The aprons are, from left to right, the rising sun (president), plow (vice president), cotton boll (secretary), reporter (US and NFA flags), Booker T. Washington (treasurer), and owl (advisor).

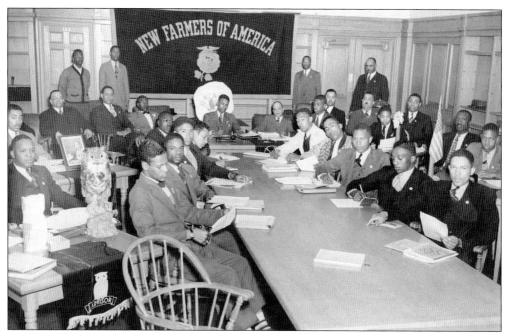

Student officers from various NFA state associations hold a business meeting in order to plan the national NFA convention. Planning for the national convention was a very meticulous process that involved both the student and adult officers.

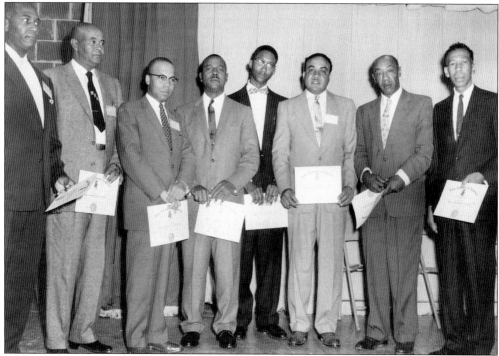

Eight men who contributed greatly to the New Farmers of America receive their honorary superior farmer degree. This distinction represented the highest award to non-NFA members for contributions to the organization.

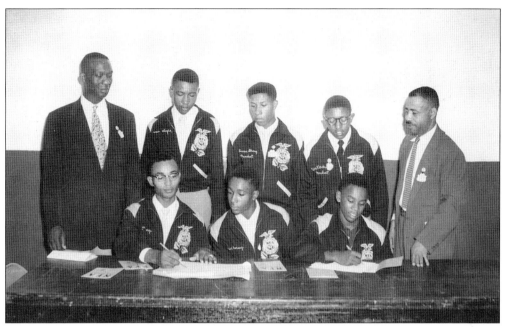

Pictured here are the 1955–1956 national NFA student officer team with adult officers G.W. Conoly, national NFA advisor (standing left), and W.T. Johnson, national executive treasurer (standing right). The student officers represented the states of Texas, Georgia, Louisiana, Virginia, Alabama, North Carolina, and Arkansas.

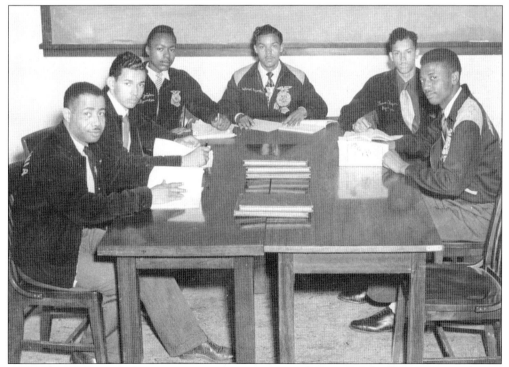

W.T. Johnson, national executive treasurer, meets with a national officer team to discuss association business.

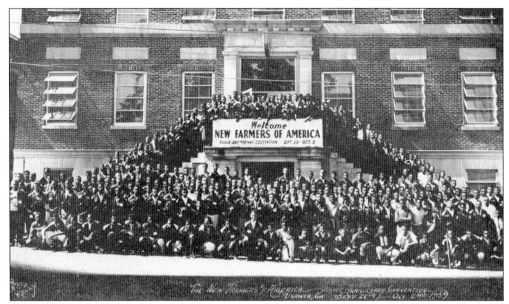

The year 1959 marked the silver anniversary convention for the New Farmers of America. Pictured here are conference attendees and delegates from all states in the NFA. The convention took place September 28–October 3, 1959, in Atlanta, Georgia.

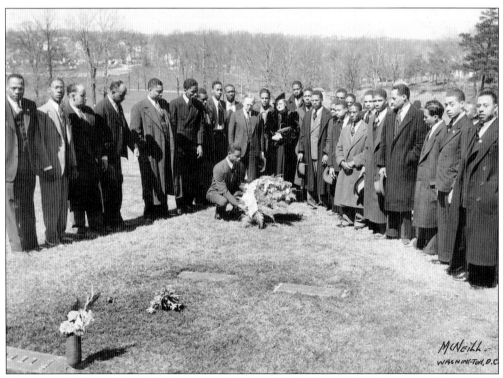

The untimely death of Dr. H.O. Sargent on February 12, 1936, as result of an automobile accident was a sad moment in the history of the New Farmers of America. In this photograph, the 1941–1942 national NFA officers and adult officials lay a wreath on his grave.

Pictured here are, from left to right, Marvin Rountree, 1956–1957 national NFA president; James Wright, first national vice president, 1955–1956; Jim Hunt, 1955–1956 North Carolina Association president and future governor of North Carolina; and the 1955–1956 North Carolina New Home Makers of America president.

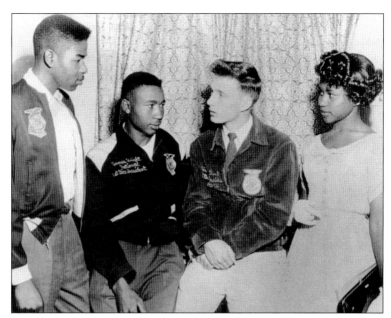

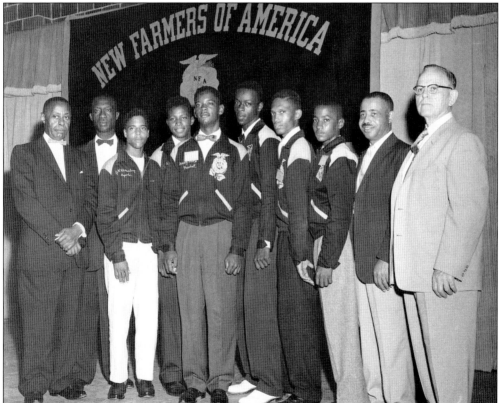

The 1957–1958 national NFA officer team pictured here represented the states of Alabama, Virginia, Georgia, Louisiana, South Carolina, Texas, and Tennessee. Also pictured are the NFA adult officers, Dr. E.M. Norris (far left), G.W. Conoly (second from left), W.T. Johnson (second from right), and W.N. Elam (far right).

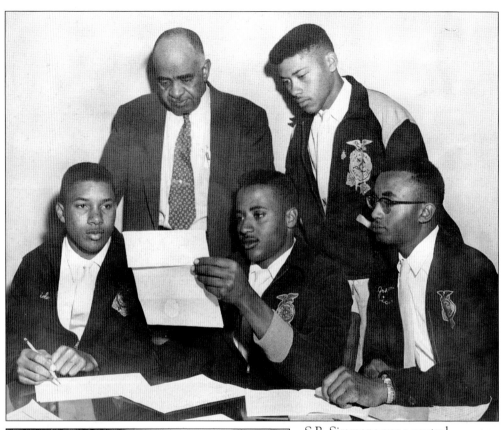

S.B. Simmons was a central figure in the growth of the New Farmers of America, in particular the development of its student officers, who were at the heart of the organization's leadership. Here, Simmons advises a group of NFA officers on a business matter.

The North Carolina Association presented gold NFA pins to three former members who at the time of this photograph were leaders in the farmer training program. Pictured from bottom to top are W.T. Johnson, teacher education at North Carolina A&T State University; R.E. Jones, North Carolina agent for Black extension work; and R.W. Newson, Virginia agent for Black extension work. The pins were presented by J.R. Thomas of Virginia State College, NFA national executive secretary.

The 1964 national NFA convention represented the 30th and next-to-last convention of the New Farmers of America. Here, student delegates from the various state associations pose in front of the Municipal Auditorium in Atlanta. Beginning in 1949, all conventions were held in Atlanta.

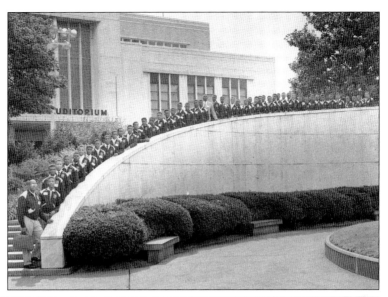

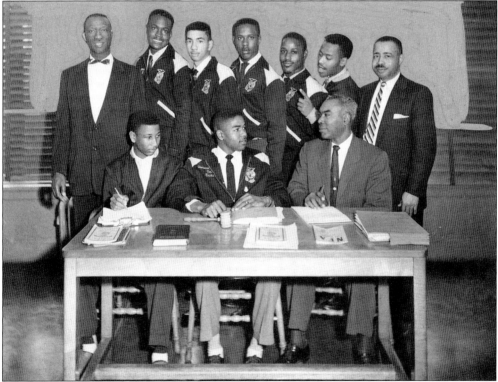

In this photograph is the 1957 NFA national officer team. From left to right are (seated) Robert Hillard, Louisiana, national secretary; Marvin Rountree, North Carolina, national president; and J.R. Powell, Texas, national executive secretary; (standing) G.W. Conoly, Florida, national advisor; James Donaldson, Florida, national vice president; William Johnson, South Carolina, national reporter; Lewis Gibson, Arkansas, national vice president; Paul Hull, Maryland, national vice president; Calvin McCarroll, Alabama, national treasurer; and W.T. Johnson, North Carolina, national executive treasurer.

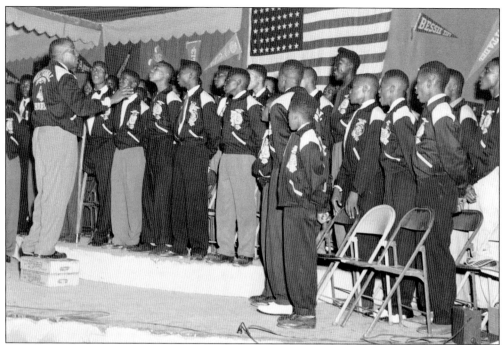

The NFA National Chorus was a collective body of student members representing every state association within the organization. In this photograph, the chorus performs at a national NFA convention, with all members in official dress. The chorus provided entertainment and was a major feature of each national convention.

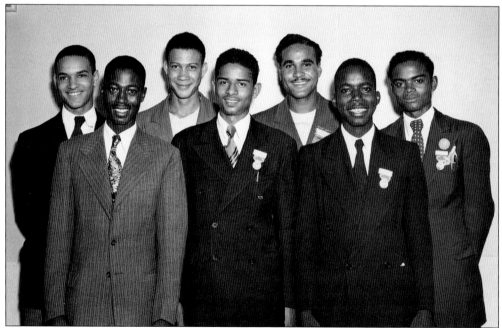

Student delegates representing the various state associations comprised the attendees of each national convention. In this photograph are student delegates at the 1947 convention. Delegates represented the interests of their respective state associations.

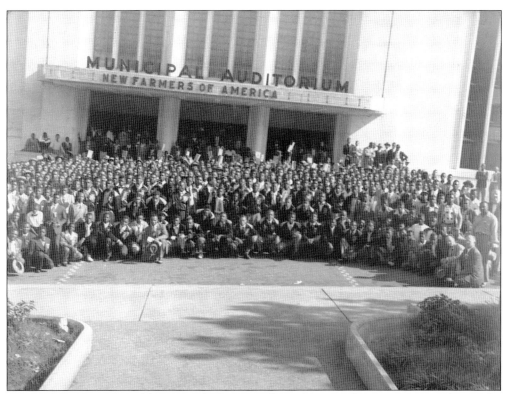

Pictured here are student delegates and advisors at the 1951 national convention in Atlanta. The convention attendees are in front of Municipal Auditorium, which was the long-standing home of the convention beginning in 1949.

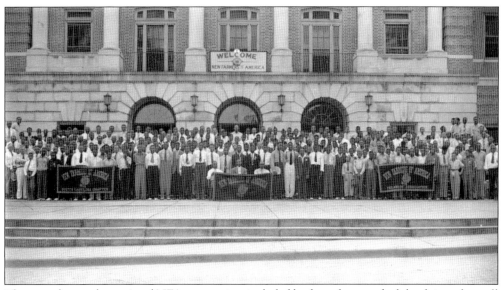

The attendees at the national NFA convention included both students and adult advisors from all state associations. Pictured here are state association delegates from South Carolina and Delaware at a national convention around the 1940s.

The *NFA Guide* and meeting gavel could be found at any NFA chapter meeting. In this image, chapter officers hold the meeting gavel and copies of the guide, which provided the core guidelines for the organization.

Proficiency awards were a major award category for the New Farmers of America, recognizing achievement in farm-based enterprises. The achievement of these awards was a major accomplishment for NFA members. Pictured here are proficiency award winners around the 1950s.

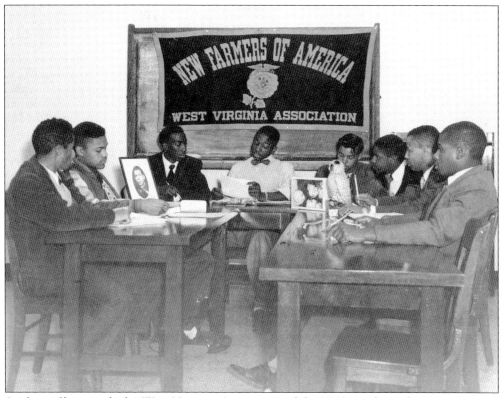

Student officers with the West Virginia Association of the NFA conduct a business meeting. Displayed on the table are various officer emblems: Booker T. Washington (treasurer), cotton boll (secretary), owl (advisor), and plow (vice president).

The 23rd national NFA convention, which took place September 30– October 4, 1957, in Atlanta, included representation from all state associations. In this photograph are two student officer delegates from Florida, which had one of the NFA's largest memberships.

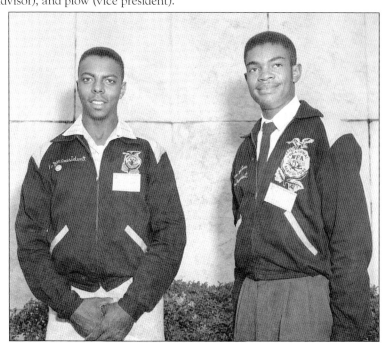

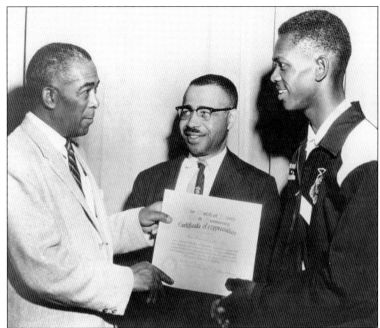

During the 1958 national convention, the National Foundation for Infantile Paralysis presented the NFA with a certificate of appreciation. From left to right are Charles H. Bynum, director, interracial activities, National Foundation for Infantile Paralysis; W.T. Johnson Sr., executive secretary of the NFA; and Douglas Miller, state NFA president.

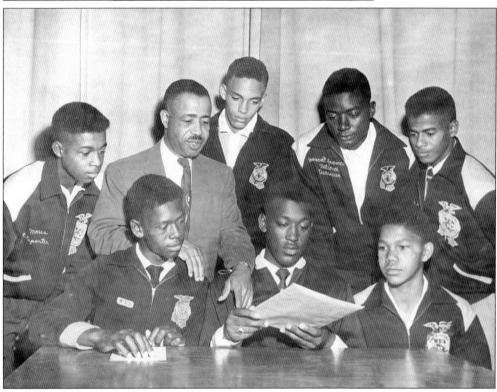

W.T. Johnson (standing, second from left), the executive treasurer for the NFA, is pictured with the 1955–1956 national NFA officer team. The student officers were from Texas, Georgia, Louisiana, Virginia, Alabama, North Carolina, and Arkansas. Election as a national officer was a major honor for members.

Adult officers G.W. Conoly of Florida (standing far left), the national advisor, and W.T. Johnson of North Carolina (standing far right), the executive treasurer for the NFA, pose with the 1955–1956 national NFA officer team. The student officers were from Texas, Georgia, Louisiana, Virginia, Alabama, North Carolina, and Arkansas.

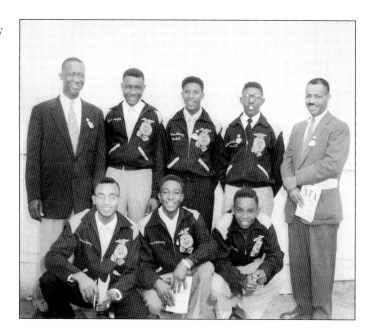

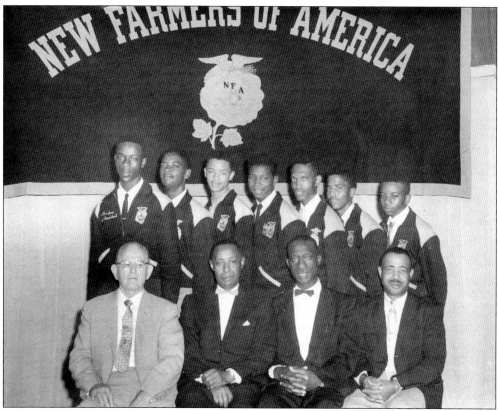

The national student officers standing in the second row are accompanied by adult officers (seated from left to right) W.N. Elam, Dr. E.M. Norris, G.W. Conoly, and W.T. Johnson.

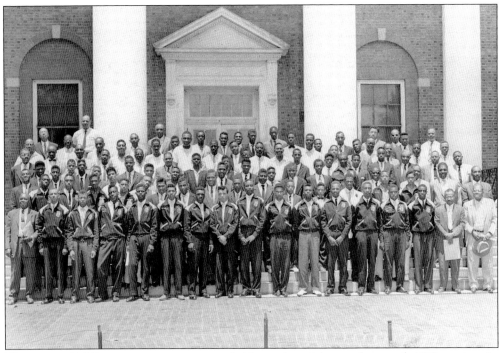

The national NFA conventions were attended by student delegates from each NFA section. In this photograph, student officers from different state associations are represented.

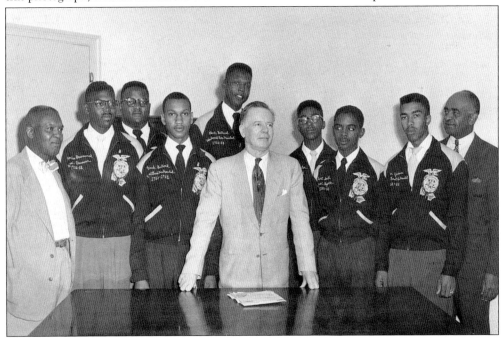

Each year, as a component of their professional development as new officers, national NFA officers would visit the US Department of Health, Education, and Welfare. Here, S.M. Brownell (center), commissioner of education, meets with the 1952–1953 NFA national officer team comprised of members from Kentucky, Louisiana, North Carolina, Texas, Georgia, West Virginia, and Mississippi.

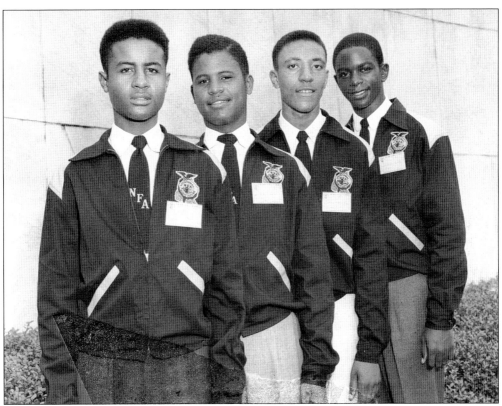

Members of the Texas Association of the NFA attend the 23rd annual national convention in 1957 in Atlanta. The convention took place September 30–October 4.

The student vice president from the North Carolina Association leads a business session at the annual state meeting. All North Carolina Association meetings took place at North Carolina A&T State University in Greensboro, North Carolina.

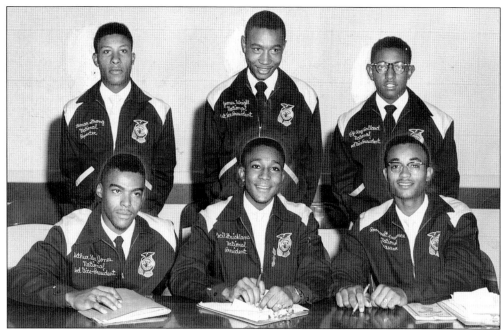

The 1955–1956 national NFA student officers were from Texas, Georgia, Louisiana, Virginia, Alabama, North Carolina, and Arkansas. Pictured from left to right are (seated) Arthur Lee Jones, national third vice president; Cecil Strickland, national president; and Roosevelt Lawrence, national treasurer; (standing) Leman Strong, national reporter; James Wright, national first vice president; and Billy Ray Ballard, national second vice president.

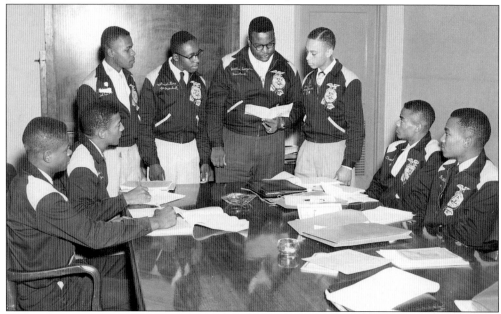

Visits to Washington, DC, were a major component of national NFA officer training. In this photograph, the 1951–1952 national NFA officers conduct a convention planning meeting. The states of North Carolina, Texas, Virginia, Georgia, Louisiana, Florida, and West Virginia were represented on the national officer team.

The 1952–1953 North Carolina Association officers are, from left to right, Weddie Gabriel, Walter Hill, Frank Bullock, Calvin Devranx, and Victor Dunbar.

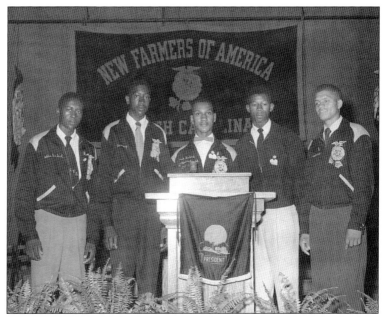

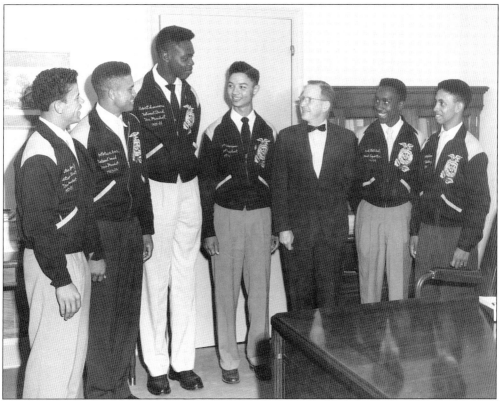

S.M. Brownell, commissioner of education for the US Department of Health, Education, and Welfare, greets the national officers of the New Farmers of America in his office. The young men, along with their national adult officers, held a four-day meeting August 2–5, 1954, to make plans for their national convention and program of work for the coming year.

THE NATIONAL CONVENTIONS

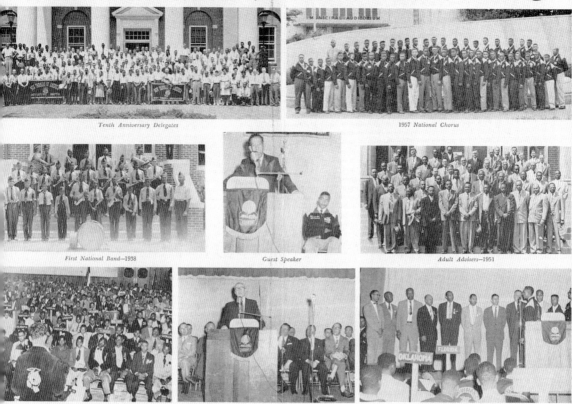

Tenth Anniversary Delegates

1957 National Chorus

First National Band—1938

Guest Speaker

Adult Advisers—1951

In Session—1950

Foundation Donors

Honorary Superior Farmers

The national NFA conventions were the pinnacle of all meetings, consisting of business sessions, competitive events, award ceremonies, and entertainment. The convention took place in September or October each year. Pictured are, from left to right, (top row) members from the Maryland and West Virginia Associations of the NFA at the 10th annual national convention and the 1957 National Chorus; (center row) the first National Band in 1938, a convention keynote speaker, and adult advisors in 1951; (bottom row) a business session at the 1950 convention, a foundation donors session, and the honorary superior farmers ceremony.

Three

COTTON BOLL, CLASSROOM, AND COMMUNITY

The "Cotton Boll" organization of the New Farmers of America was an integral component of both the secondary vocational agricultural education program and the larger community because it was through this organization that the rural communities' future agricultural leaders and family men were developed. Within the NFA and secondary vocational agricultural education program, students had the opportunity to learn skills related to crop production and soil conservation, agricultural mechanics, livestock husbandry, farm electrification, farm business management, and leadership development, just to name a few.

The local NFA plan of work involved supervised farming practices, community improvement, leadership training, earning and savings, scholarship, and recreation. One major example of community engagement was the NFA's assistance in the war effort during World War II. The NFA sold thousands of dollars in bonds and stamps, collected thousands of cans of food for the European theater of battle, and developed community canneries. Other efforts of the NFA in support of the war effort involved farm machinery repair and natural resources conservation. Another example is the North Carolina Association's annual fundraising support to the Colored Orphanage of Oxford, North Carolina. This was one of the largest orphanages for Black children in America. The NFA plan of work also provided for work in home repair and improvement.

The New Farmers of America produced many students who would go on to college to major in agricultural science and other subjects, with numerous former members becoming educators, administrators, extension professionals, state and national government agricultural professionals, farmers, and agribusiness professionals, all having great impact upon their communities.

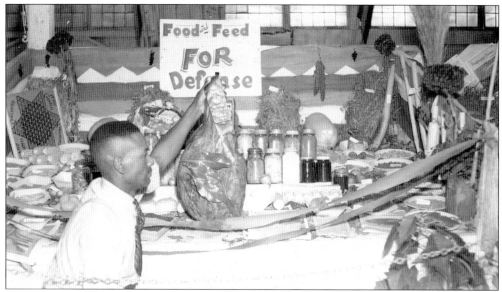

One of the greatest accomplishments in the history of the New Farmers of America was its contribution to the war effort on the home front during World War II, including the production, collection, and distribution of food for local needs and for Europe. In this photograph, an NFA member displays a first-place ham as a part of his chapter's Food and Feed for Defense exhibit at the 1941 Greensboro Fair.

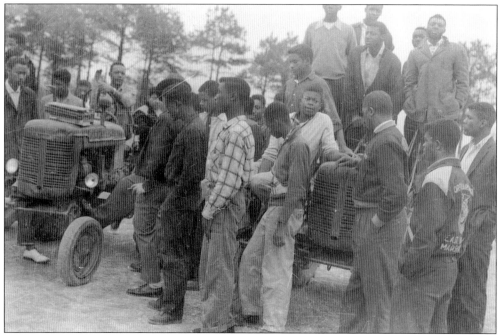

Agricultural mechanics was not only a core component of the secondary vocational agricultural education program's instruction, but also the NFA's through its Farm Mechanics Award. Here, a group of vocational agricultural education students work on two Farmall tractors in their agricultural mechanics class.

One of the major goals of the New Farmers of America was the encouragement of members to establish farming enterprises, which in turn would impact local community development and economics. In this photograph, the J.H. Gunn High School NFA chapter in Charlotte, North Carolina, displays an exhibit showing how community income was increased through improved farming practices during the 1958–1959 school year.

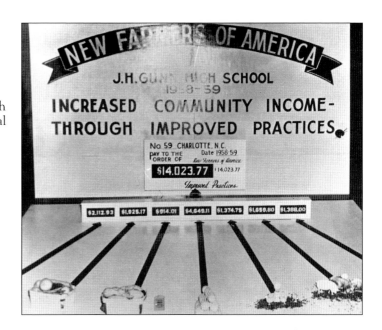

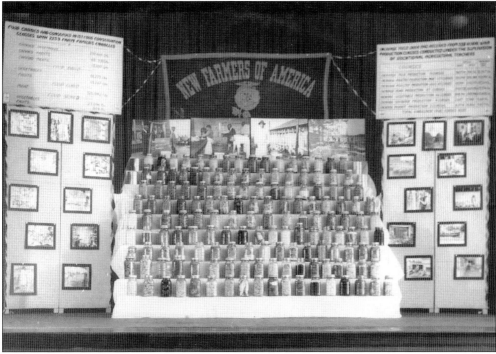

To stimulate food production during World War II, the US Congress provided appropriations to the US Office of Education's Agricultural Education Branch to establish the Rural War Production Training Program. Through this program, short courses concerning food production were conducted, which resulted in increased crop production and the development of school-community canneries. Pictured is an NFA exhibit displaying the production results of food canned through food conversation courses and increased crop yields throughout 1942 as a result of war production courses.

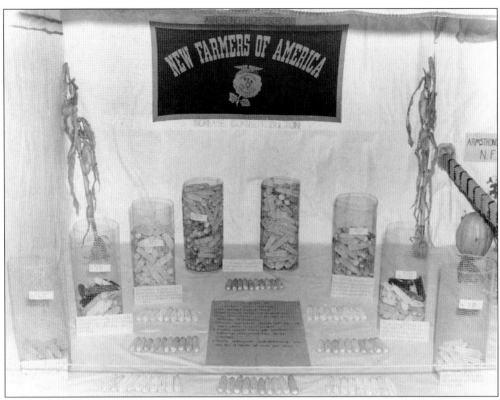

THE NATIONAL ORGANIZATION FOR NEGRO STUDENTS
STUDYING VOCATIONAL AGRICULTURE

WE PLEDGE:

To keep physically and mentally fit.

To serve in the armed forces if and when called.

To produce our quota of food for victory.

To collect and sell scrap materials.

To purchase defense stamps and bonds.

To repair farm machinery.

To conserve human and natural resources.

To develop morale.

One of the purposes of the NFA was to encourage the intelligent choice of farming occupations, which included the adoption of new agricultural technologies. In this photograph, a display by the Armstrong High School NFA chapter shows the increase in corn production witnessed by members through the planting of various hybrid corn varieties.

On March 31, 1942, the national board of trustees and the advisory council of the New Farmers of America adopted the Tennessee Association of the NFA's war pledge for the national organization. The pledge emphasized values such as being physically and mentally fit, morale development, food production, the collection and selling of scrap metal, the purchase of defense stamps and bonds, natural resources conservation, and farm machinery repair.

William Byrd, a NFA member, files a new ring to install in a tractor piston under the supervision of W.J. Fisher, agricultural education teacher and defense classes supervisor in Alamance County, North Carolina. The tractor was being completely overhauled by Byrd and other members of his class. Agricultural mechanics and farm machinery repair were major activities in the vocational agriculture program.

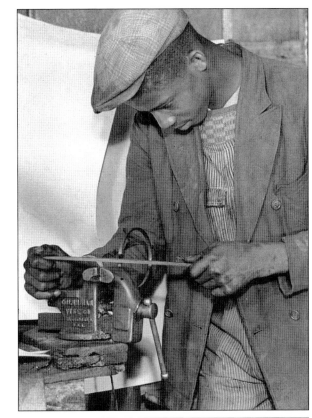

One of the stated purposes of the NFA was to encourage the improvement of the home, the farm, and surroundings. Pictured from left to right are Mr. and Mrs. Harrison, their son Bennie, and Prof. A.N. McCoy. The Harrisons were proud of their modern dairy barn built by McCoy and his students in the local NFA chapter.

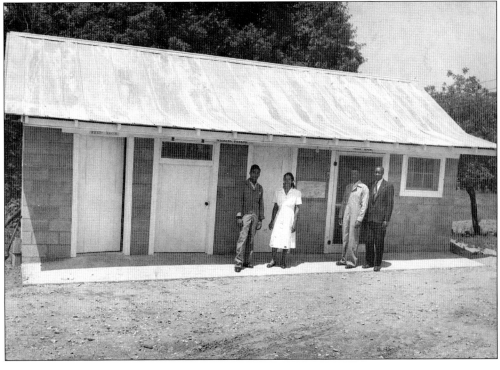

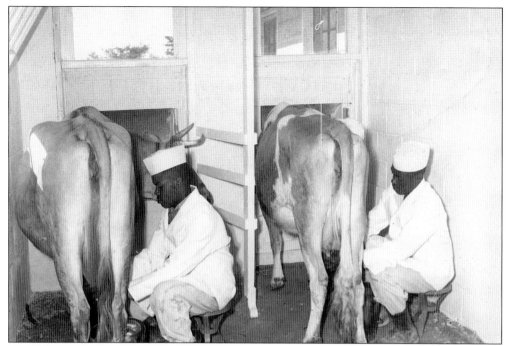

Bennie Harrison and his brother do the milking in their new barn built by the local vocational agricultural education teacher, A.N. McCoy. McCoy built barns such as this one each year to provide training for his students and to help farmers improve their income.

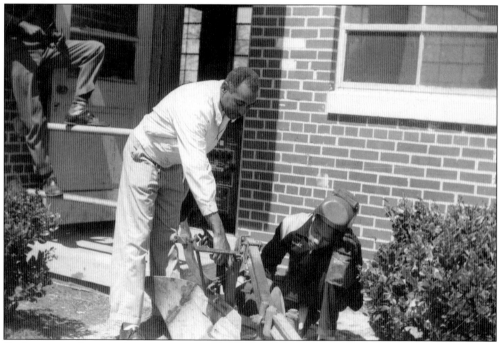

Proficiency in farm mechanics was a major skill emphasized by the NFA and the local vocational agricultural education program. In 1962, a vocational agricultural educator shows his student, wearing an NFA jacket, how to properly do a welding repair on a plow.

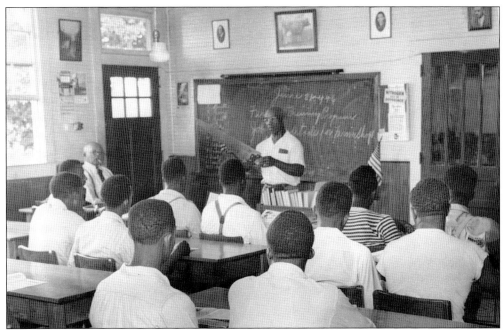

The Veteran Farmer Training Program was a major component of the local vocational agricultural education program. The On the Job Farmer Training in public schools was a result of Public Law 346 and Public Law 16. Here, an agricultural education teacher is giving students instruction in fitting saws.

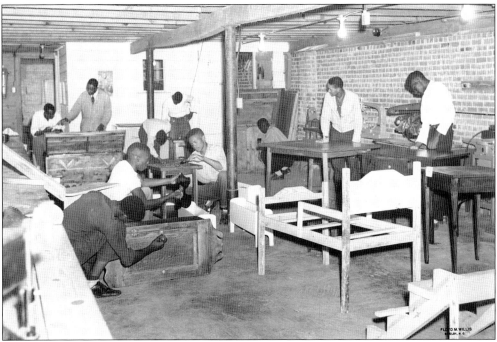

Woodworking was a major area of agricultural mechanic instruction, an imperative skill for farm enterprises. Here, vocational agricultural students work on a variety of wood projects in the agricultural shop, including tables, cabinets, and wood staining for the home and farm.

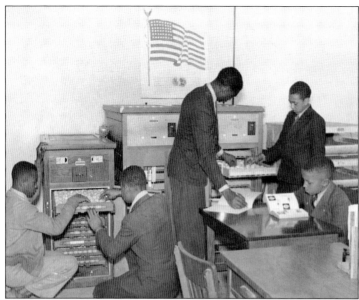

Poultry production was a major contest program within the NFA as well as a skill taught within the secondary vocational education program. One imperative skill that NFA members were expected to learn was the grading of eggs to determine egg quality, as demonstrated here.

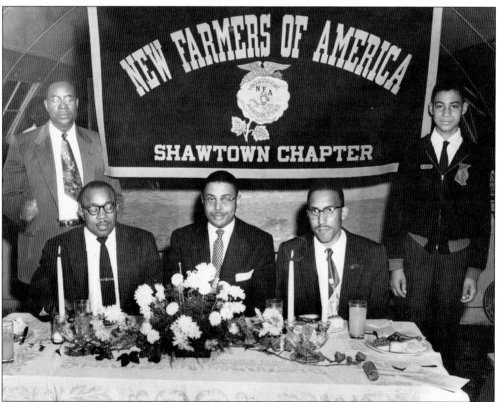

Chapter banquets were a major event for local NFA chapters. On April 5, 1955, the Shawtown High School chapter hosted its annual Parents Banquet. From left to right are (seated) William M. Freeman, assistant teacher of agriculture; Reverend Collins; the guest speaker, B. Byrd, pastor at First Congregational Church in Dudley, North Carolina; and C.R. Downing, vocational agriculture teacher; (standing) G.T. Swinson, principal, and Haywood Atkins, chapter president.

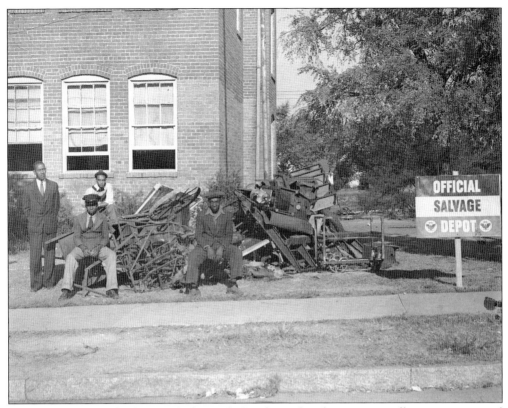

The Mary Potter School in Oxford, North Carolina, played its part in collecting scrap metal during World War II. Here, school principal H.S. Davis and three local community members stand with the local NFA chapter's contribution to the salvage campaign.

Agriculture at its core is an applied science, whether studying the plant, soil, animal, or environmental science aspects of the industry. In this photograph, NFA members view various slides with a projector during their vocational agricultural education class.

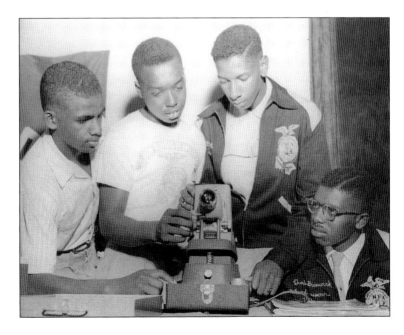

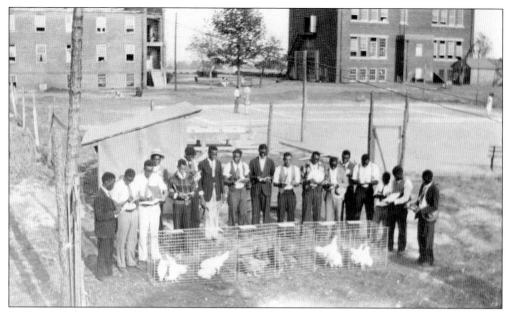

Poultry judging and evaluation were essential skills learned within the secondary vocational agricultural education program and could be applied on the farm. In this photograph, students in a local vocational agricultural education program evaluate poultry.

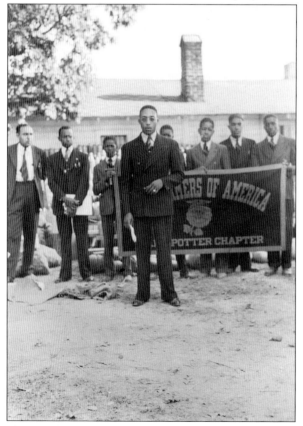

One of the major values emphasized by the NFA was service. For Thanksgiving 1941, the North Carolina Association provided cash and food totaling $2,500 in value to the Colored Orphanage of North Carolina in Oxford. Allen Spaulding (center), a former student at the orphanage and a former NFA member, presented the gifts. Also pictured are president Francis (left) and officers of the Mary Potter Chapter in Oxford.

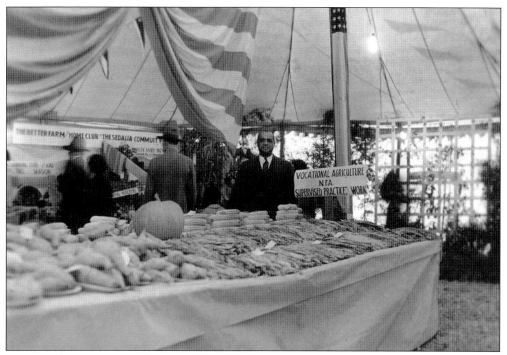

Supervised farming practice was a major activity for NFA members in preparing them to have proficiency in owning their own agricultural enterprise. In this image, the commodities grown through a North Carolina NFA chapter's supervised practice work are displayed.

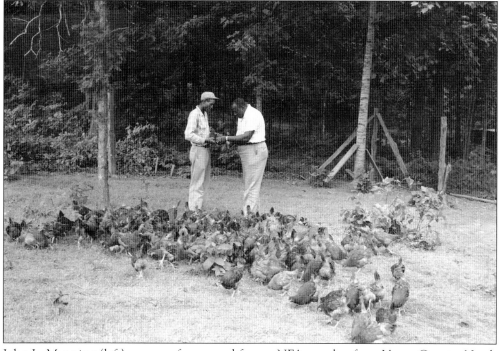

John L. Manning (left), a young farmer and former NFA member from Vance County, North Carolina, culls a flock of young birds with the aid of his former vocational agricultural teacher.

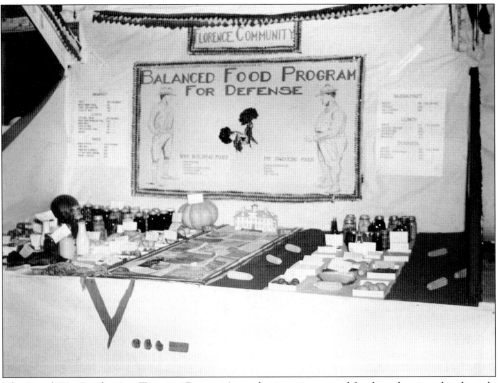

The Rural War Production Training Program's emphasis on increased food production also directly resulted in a campaign for a balanced diet. This 1942 exhibit by the Florence Community NFA program encourages a balanced food program during World War II.

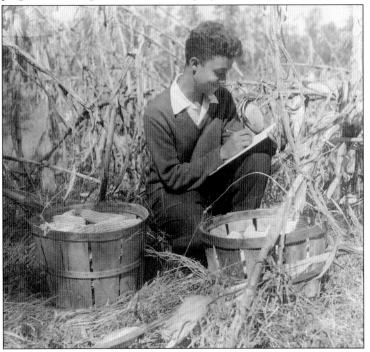

The supervised farming practice portion of the secondary vocational agricultural education program was designed to develop the proficiency of students in farming entrepreneurship. This vocational agricultural education student updates his production records for his supervised farming practice project, focusing on corn production.

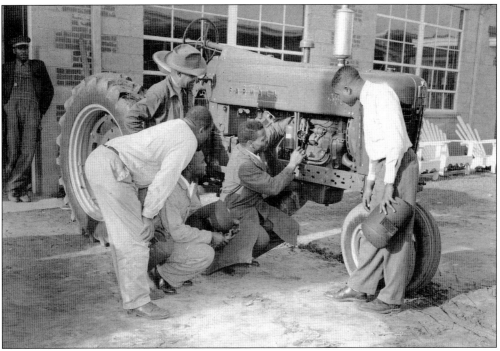

The Veteran Farmer Training Program provided a venue for former New Farmers of America members to receive up-to-date instruction in the latest agricultural production techniques, which included the repair of farm machinery. The veteran farmer trainer in this photograph provides instruction on the repair of a Farmall tractor at the local vocational agricultural education program.

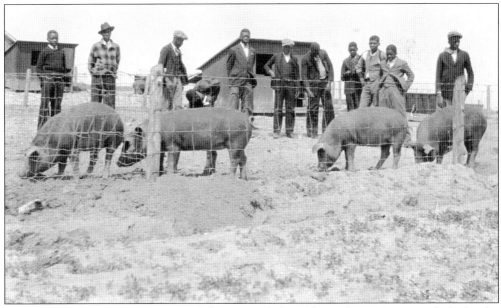

The evaluation of livestock was a skill promoted throughout the NFA, particularly for the improvement of animals. Swine production was a key livestock enterprise for NFA members and their families, and required the ability to evaluate animals for production quality.

Instruction in crop production was an essential skill taught in the secondary vocational agricultural education program. Here, vocational agricultural education students analyze the plant and soil conditions of a field for crop production.

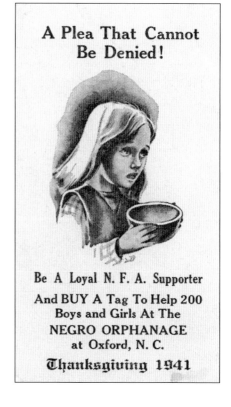

This tag was used by members of the North Carolina Association to raise more than $750 in 1941 for the Colored Orphanage of North Carolina in Oxford for Thanksgiving. This effort supported 200 boys and girls at the orphanage.

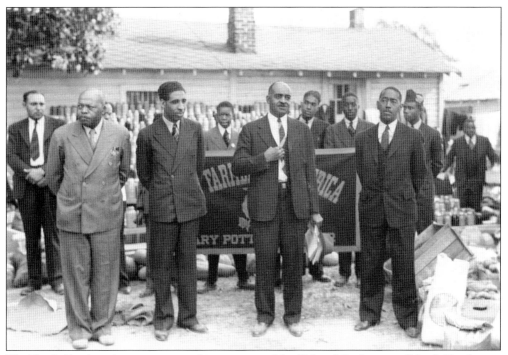

The North Carolina Association was a big supporter of the Colored Orphanage of North Carolina in Oxford. S.B. Simmons (center holding hat), NFA state advisor for the North Carolina Association, presented gifts to the orphanage in 1941 along with student officers from the Mary Potter Chapter. The gifts included cash and food.

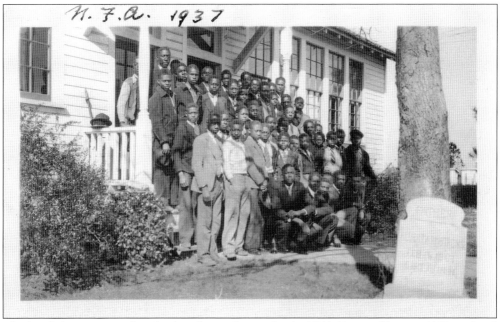

The local chapters served as the foundational units for the NFA. Pictured here in 1937 is a local chapter from North Carolina.

One of the stated purposes of the NFA was to encourage members to improve the home, the farm, and surroundings. This was largely done through the farm and home improvement awards program. Pictured here in 1954, Frank Bullock of Henderson, North Carolina, works on lawn chairs as part of that program.

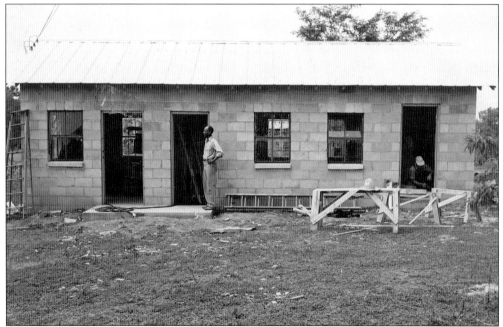

Claude Taylor of Vance County, North Carolina, looks over his grade-A barn, the first one built in the county with the assistance of the local New Farmers of America chapter in 1954. Taylor was also a leader in the adult agricultural education program.

Claude Taylor and his son planned and worked together on the dairy and barn project. His son was a senior vocational agriculture student at Henderson and was a winner in the National Dairy Contest in 1954.

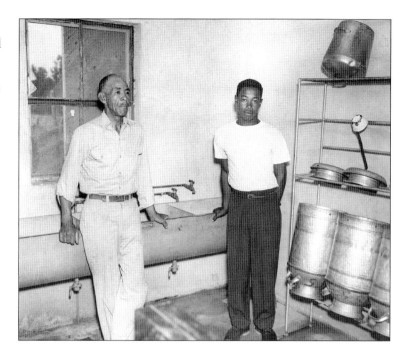

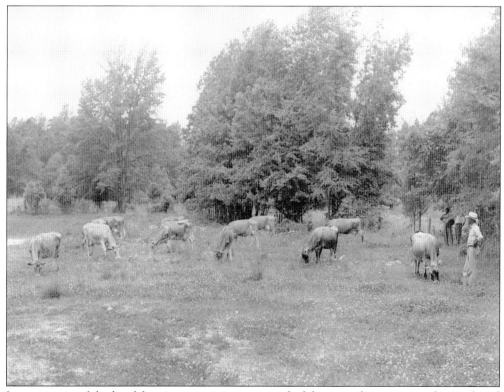

Improvement of the local farming enterprise was a goal of the secondary vocational agricultural education program. In 1954, Claude Taylor and his family realized what positive results good pasture management could mean for increased milk production and increased profits for the farmer.

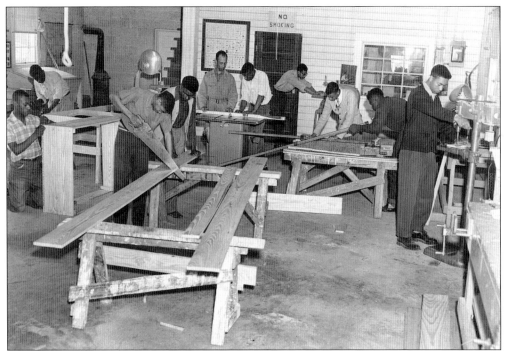

In 1954, the Roseboro Vocational Agriculture students under Professor Devane learned to make useful articles for the home as they developed essential skills in this well-equipped shop. The skills learned in the class could be taken back to their farms.

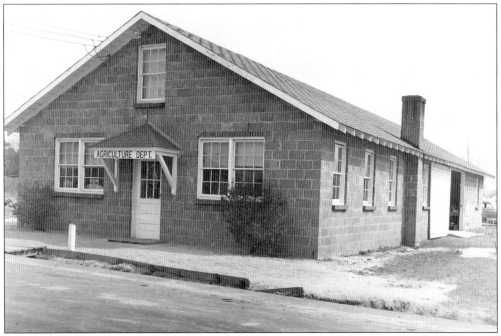

The Roseboro Vocational Agriculture building was constructed largely with funds given by Black farmers and others in the community in 1954. It was a local source of pride. The principal put up most of the cash because of his belief in the program and what it meant to the local community.

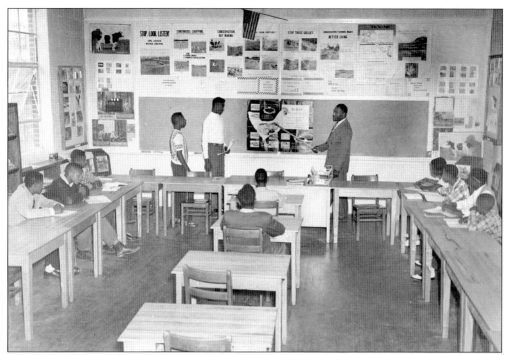

The classroom was at the heart of the secondary vocational agricultural education program. Here, T.J. Culler, secondary agricultural educator, provides instruction in his well-equipped classroom at DuBois High School in Wake Forest, North Carolina, in 1954.

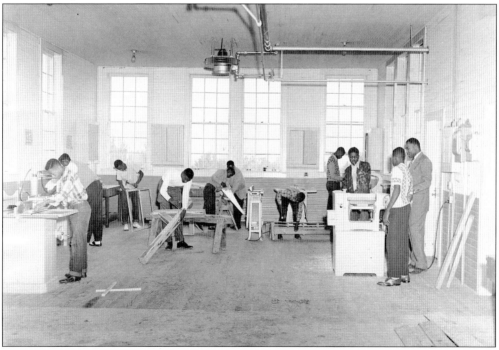

T.J. Culler, secondary agricultural educator at DuBois High School, in Wake Forest provides instruction to his students as they repair home farm machinery in the program's farm shop in 1954.

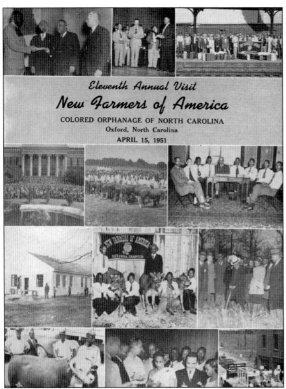

The North Carolina Association was a significant supporter of the Colored Orphanage of North Carolina in Oxford and provided annual fundraising support to the orphanage. This was one of the largest orphanages for Black children in America. This cover from the program of the 11th annual NFA day at the orphanage displays a variety of NFA activities carried out across North Carolina in 1951.

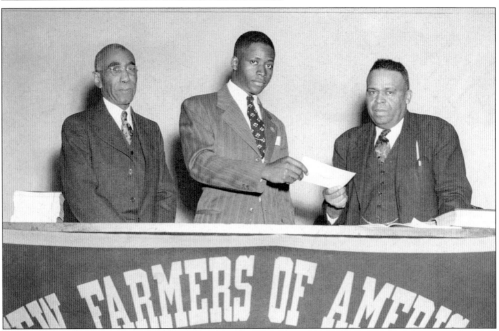

In 1951, L.J. Shipman, former state NFA president, presents Supt. T.A. Hamme of the Colored Orphanage of North Carolina with $10,000 in US bonds as a gift from the state NFA group. The plan for the funding was to construct a vocational education building on the orphanage campus in memory of the late Dr. George Washington Carver.

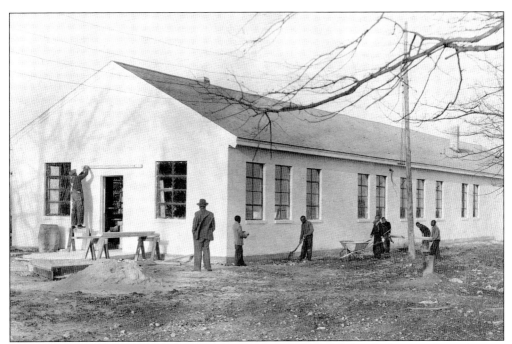

In 1951, Supt. T.J. Hamme of the Colored Orphanage of North Carolina looks on as the orphanage boys clean up around the $15,000 vocational education building that the North Carolina Association members raised money for and equipped.

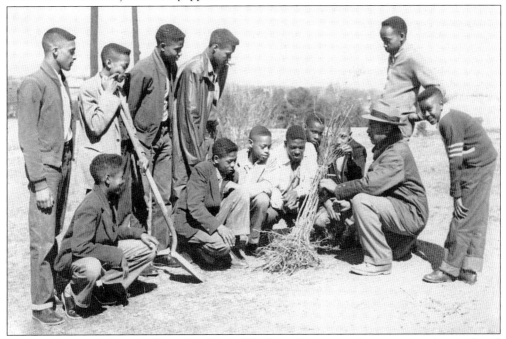

In this photograph from 1951 are Prof. R.K. Wright and his secondary vocational agricultural education students just before they planted a young orchard. Horticulture was a major subject area taught within secondary vocational agricultural education and provided NFA members with training in an applied plant science discipline.

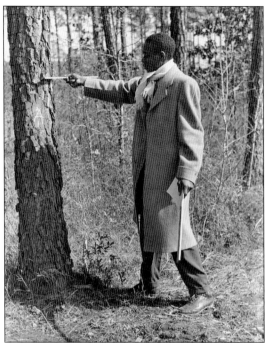

Forestry and wood harvesting were important agricultural enterprises across the various states in which the NFA was found. Here, a secondary vocational agricultural education student measures a tree.

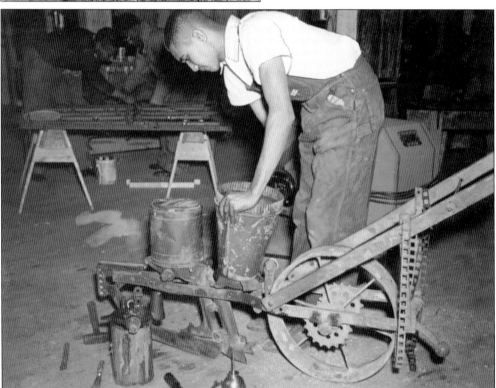

Instruction in farm machinery repair was a major skill taught in vocational agricultural education. This secondary vocational agricultural education student repairs a plow in the program's farm shop.

NFA members and advisors compete in a friendly horseshoe game, which was always a fun and anticipated activity.

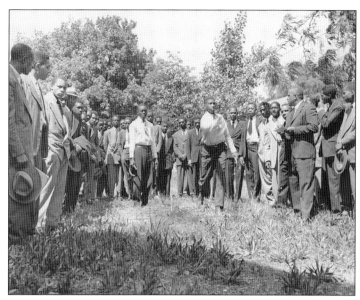

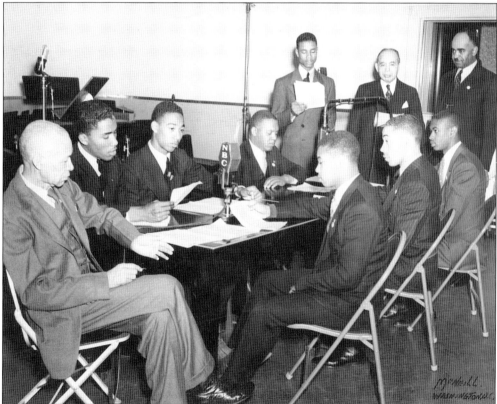

The year 1941 was a very significant one for the New Farmers of America. On April 3, the NFA went on the air over the NBC station in the nation's capital. One of the highlights of the program was the message from Pres. Franklin D. Roosevelt providing greetings, thanking them for their support in the war effort, and recognizing them for commemorating the life of Booker T. Washington, one of the world's greatest leaders.

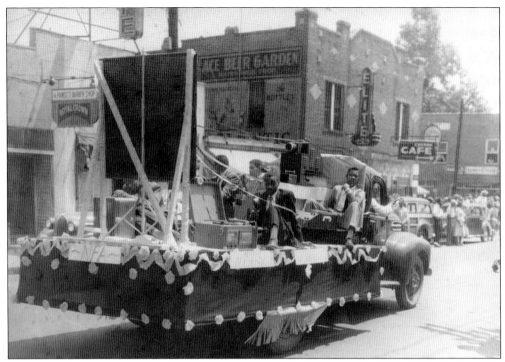

The New Farmers of America was a major part of the rural communities and small towns where the organization existed. Pictured here is an NFA float in a town parade, representing the local secondary vocational agricultural education program.

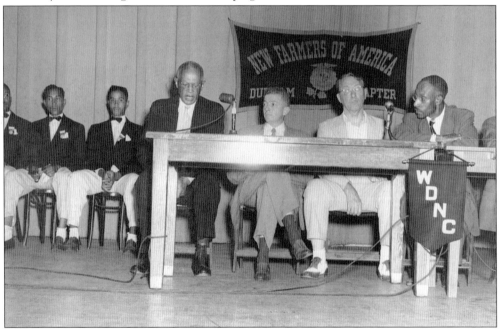

Throughout the South, NFA chapters presented special programs on April 5 in honor of the birthday of the late Dr. Booker T. Washington. The Little River Chapter of Durham, North Carolina, under Prof. J.L. Moffitt, conducted a radio program over station WDNC each year.

One of the products of the Rural War Production Training Program was the development of school-community canneries for the conservation and processing of food crops grown by local farmers. These school-community canneries represented another type of facility that local departments of vocational agriculture used to maximize interest in the Rural War Production Training Program.

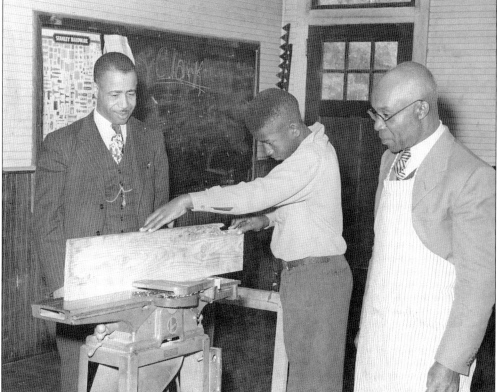

W.T. Johnson (left), assistant supervisor for Black schools in North Carolina, observes a secondary vocational agricultural education student trim a wooden board under the supervision of his agricultural education teacher.

Through the support of state and local school personnel throughout the NFA's state associations, the school-community canneries received tremendous support, and as a result were able to supply thousands of farm families with the ability to meet their own food needs, thereby releasing to the urban public, the armed forces, and the Allies greater quantities of commercially packed food crops in support of the war effort during World War II. In this photograph, state-level vocational agricultural education officials in North Carolina inspect one of the canneries.

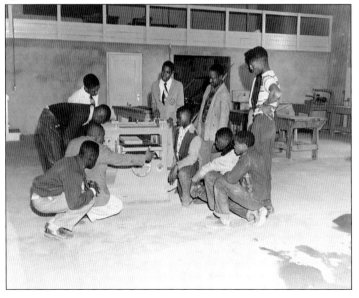

The New Farmers of America was a major component of the secondary vocational agriculture education program. Here, NFA members receive instruction in the proper procedures for operating a wood planer.

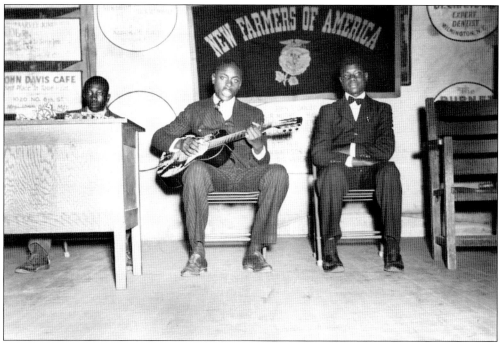

Entertainment was a recommended activity for NFA meetings at all levels and was to be included in the NFA plan of work. Shown here, members provide musical entertainment at a chapter meeting.

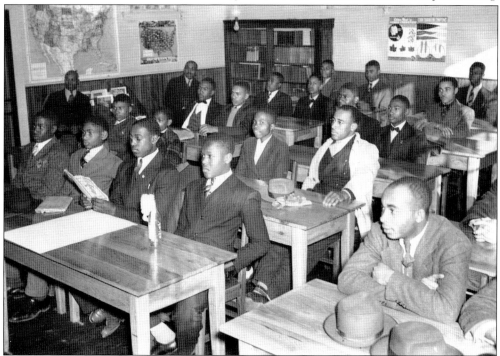

The local NFA chapter meeting was the mechanism by which all official chapter business was conducted. In this photograph, NFA members conduct a business meeting, with one member at the front center table holding the *NFA Guide*.

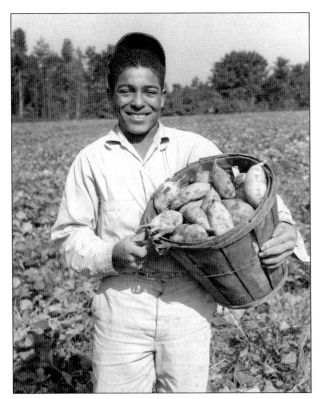

One of the central purposes of the New Farmers of America was to encourage and guide boys in the selection of the occupation of farming and become established in farming. Given this, NFA members were trained through their secondary vocational agriculture courses to produce high-quality farm produce. Sixteen-year-old NFA member Russel Deyo of Sparta, Virginia, raised sweet potatoes and tobacco on a large farm he cultivated with his father, Russel B. Deyo, in 1947. (Courtesy of IUPUI.)

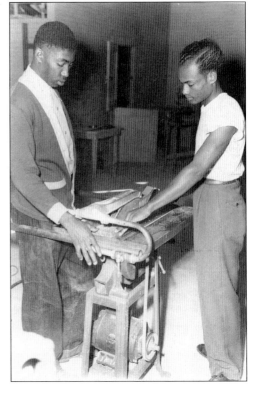

The proper operation of shop equipment was an essential skill for New Farmers of America members and for young farmers for daily practice. In this photograph, two secondary vocational agricultural education students cut boards for a shop project.

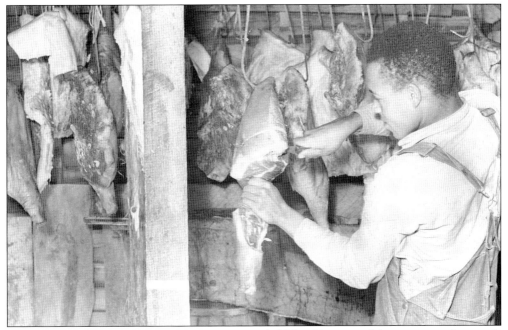

The supervised farming practice program provided New Farmers of America members with practical experience in conducting an agribusiness enterprise. Here, an NFA member cuts cured meat as part of his supervised farming project.

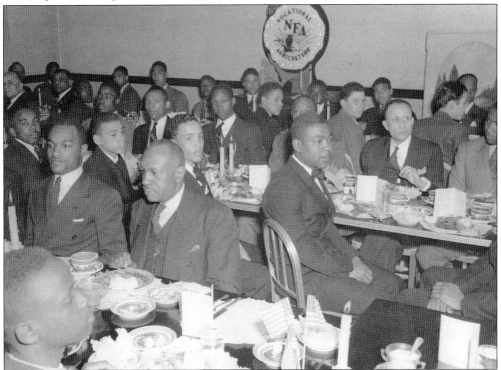

Father and son banquets were major events for some NFA chapters. The banquets also gave the local home economics program practice in catering formal activities as well.

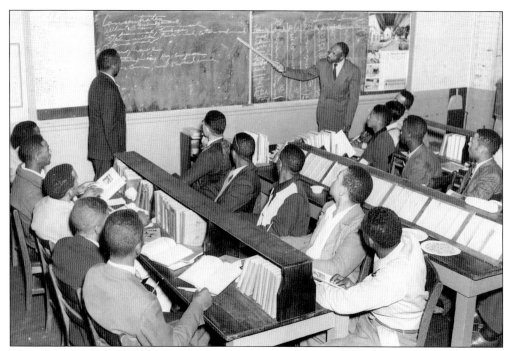

This photograph shows a group of World War II veterans being led in a discussion at the Little River School in Durham, North Carolina, by J.L. Moffitt, vocational agricultural teacher. There were 28 veterans enrolled at the Little River School Veteran Farmer Training Program.

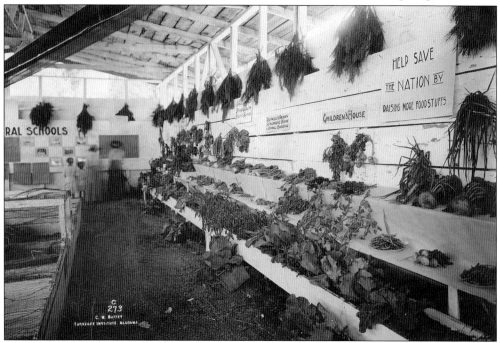

The production of foodstuffs was a major activity encouraged through the organization in an effort to support the war effort on the home front during World War II. This exhibit at the Tuskegee Institute by the NFA was an example of this effort.

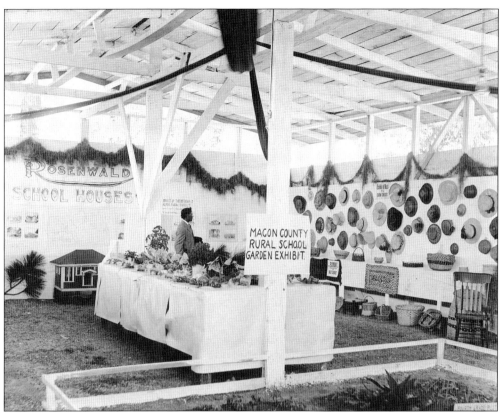

One of the mechanisms used by the NFA to promote food production was through exhibits at local county fairs. In this photograph, the local NFA chapter at the Macon County Rural School displays a garden exhibit.

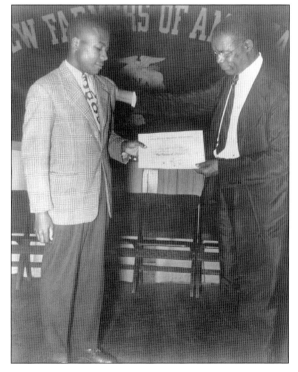

Dr. William Pickens of the US Treasury Department presents to Ollie C. Hines, national NFA president 1944–1945, a treasury citation for war bonds and stamps purchased by New Farmers of America members. The NFA was very involved in the war on the home front during World War II.

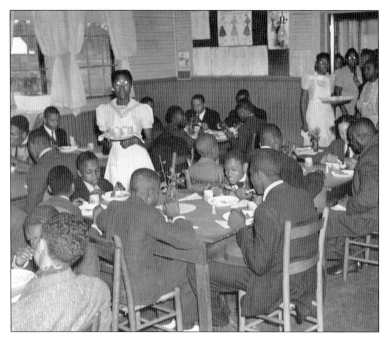

At each of the four district meetings in the North Carolina Association in 1942, the members purchased their lunch with war stamps. The host chapter members donated the food, and the home economics students, under the supervision of the teacher, prepared and served the meals. The stamps were used to purchase bonds. Through this, $125 worth of bonds was purchased by four NFA chapters.

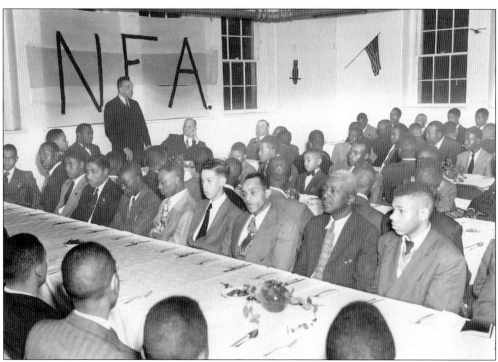

Banquets were a centerpiece of the NFA plan of work and were a way for chapters to promote their accomplishments to the local community. In addition to the NFA members and their parents, school officials such as the principal and other community leaders were normally invited.

Four

COTTON BOLL COMPETITION

A major component for the organization of the "Cotton Boll" was its competitions and award programs designed to promote the development and attainment of proficiency in farming as an enterprise and overall agricultural leadership. Two major divisions were the New Farmers of America contest and Establishment in Farming awards. The public speaking contest was designed to develop the ability of students to speak forcefully and effectively before an audience. The quartet contest was designed to develop a greater appreciation for good music, including Black spirituals. The quiz contest was established to stimulate a thorough study of the NFA constitution, *NFA Guide*, and parliamentary practice. The talent contest was designed to encourage desirable entertainment and develop musical ability.

The Establishment in Farming awards were designed primarily to assist NFA members in becoming established in farming. The H.O. Sargent Award (Young Farmer Award) was given annually to the most successful former student of vocational agriculture who had been out of school for three years but not more than 10. The awardee must have completed four years of in day-unit, all-day, or young farmers classes. The Star Superior Farmer was awarded to outstanding active members who had reached a high degree of proficiency in farming and community leadership. The Star Modern Farmer Award (state awards only) was given to the most outstanding modern farmer in each state. The Dairy Farming Award was given to the most outstanding dairy farmer in each state. The Farm Mechanics Award was designed to promote achievement in the operation and repair of farm machinery. The Farm Electrification Award was started because electricity had been extended to rural areas, and thus, it was imperative for NFA members to become familiar with opportunities, problems, and necessary skills in the use of electricity on the farm. The Farm and Home Improvement Award was designed to stimulate activities for increasing farm income and beautifying the farm home. The Soil and Water Management Award was designed to encourage approved practices in effectively managing soil and water resources. Other major competitive activities included livestock shows, ham and egg shows, and land judging.

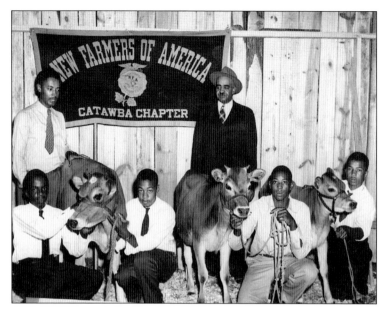

The showing of livestock was a major New Farmers of America activity. In this photograph, students from the Catawba Rosenwald School exhibit calves at the Goldsboro Dairy Show in 1951, with S.B. Simmons, assistant supervisor of agricultural education in Black schools in North Carolina from 1930 to 1957, looking on.

The improvement of cattle breeding within the agricultural industry was a goal of Sears, Roebuck and Company, which had major agricultural interests and sales. To accomplish this goal, Sears, through its foundation, provided the NFA in North Carolina with eight registered Hereford bulls, which were then used to sire calves across the state. Here, an NFA member shows a champion NFA Sears bull in 1951.

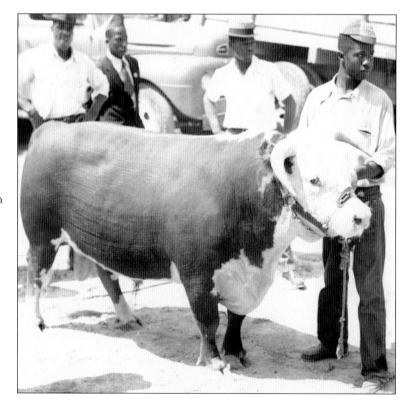

Having the ability to critically analyze swine to determine if they met market standards was an imperative skill for young farmers trying to start profitable enterprises. The livestock judging contest provided a venue to hone these essential skills. Here, an NFA member judges a market hog at a state-level competition.

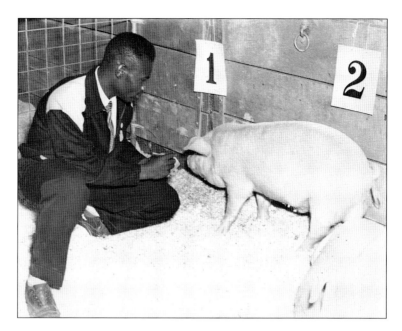

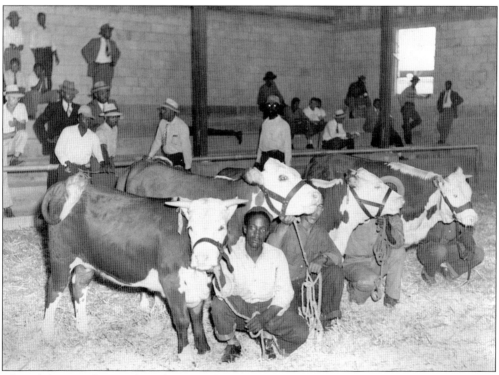

The exhibition of livestock is a long-standing tradition within the agricultural industry, allowing individuals to competitively showcase animals they raised according to industry standards with the goal of obtaining the best in show designation, which came with prize money and ribbons. In this image, NFA members exhibit cattle at the North Carolina A&T State University farm around the 1950s.

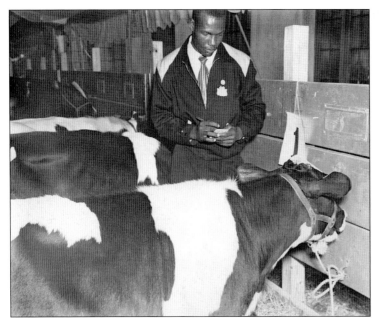

Dairy farming was a major agricultural enterprise for African American farmers during the era of the NFA. Given this, it was imperative that NFA members—and in particular aspiring young dairy farmers—have the ability to evaluate dairy animals for quality and milk production potential. This NFA member judges a Holstein cow during a dairy judging contest for its quality and conformation.

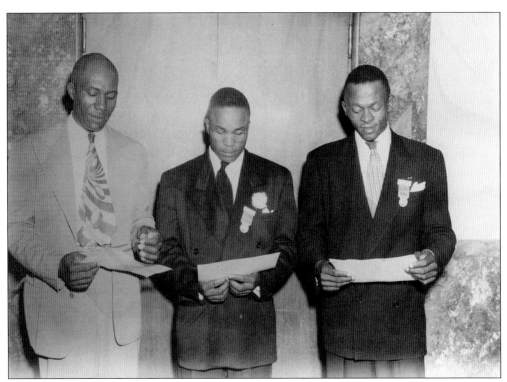

The H.O. Sargent Award was given annually to the most successful former student of vocational agriculture, who had been out of public school at least three years and not more than 10 and who had completed four years of instruction in day-unit, all-day, or young farmer classes. Shown here in 1951, H.O. Sargent Award recipients receive their awards at the national convention.

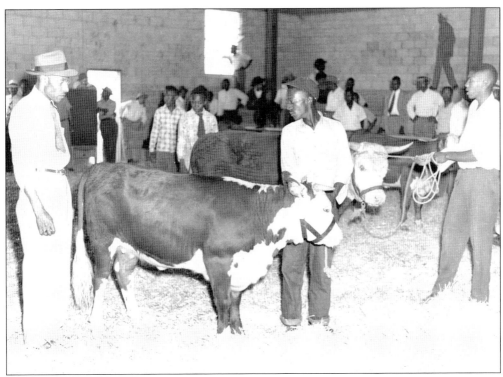

Sears, Roebuck and Company's investment in Hereford cattle improvement afforded many NFA members the opportunity to show cattle using high-quality breeding stock. As with any livestock exhibition, the goal was to raise an animal that would be judged as best in show. Here, NFA members show Hereford beef cows at the North Carolina A&T beef cattle show around the 1950s.

Supervised farming practices represented the secondary vocational agricultural education student's experiential learning project beyond everyday classroom instruction. This could involve a variety of projects, such as in this photograph of two NFA members raising a Hereford calf.

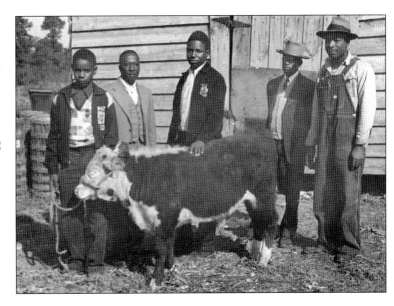

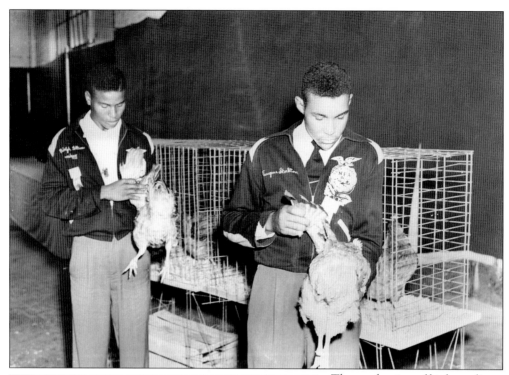

The production of high-quality poultry birds was imperative for farmers. To provide secondary vocational agricultural education students with practice in how to evaluate poultry for production quality, NFA members participated in the poultry judging contest. For the contest, industry standards for production and management were used as the basis for the competition. The two NFA members pictured here judge the quality of each bird to determine which is of the highest quality.

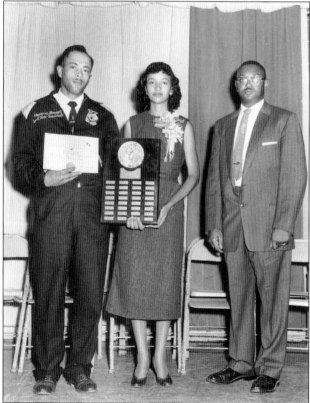

The H.O. Sargent Award, also known as the Young Farmer Award, was one of the NFA's Establishment in Farming awards. It was given each year to the most successful former student of vocational agriculture. The award winner from 1957 is pictured at left.

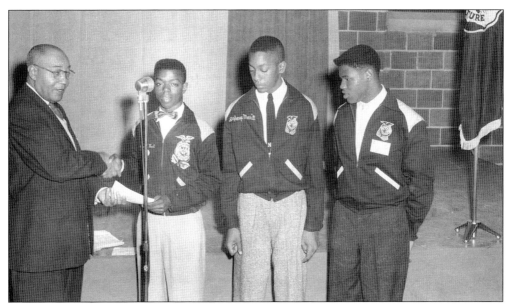

Each year at both the state and national levels, NFA members received recognition for accomplishment in various areas. These included both the NFA contest programming and the Establishment in Farming awards. Awards and recognition were decided by a plethora of individuals such as agricultural industry professionals, local and state agricultural officials, agricultural professors, and others using established criteria. In this photograph, three NFA members receive recognition at the annual national convention from an adult agricultural education official.

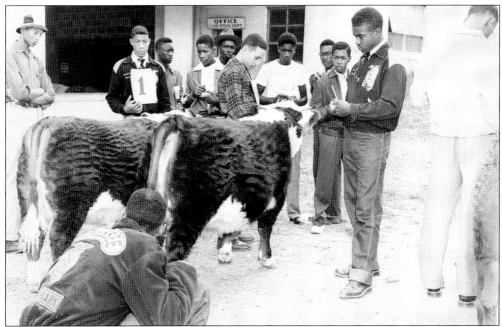

New Farmers of America members from all state associations participated in the national competitions for livestock judging, which were among the most popular competitions. Approximately 1,000 individuals attended each national convention. Here, members of the Tennessee Association judge two Hereford cattle along with other NFA members.

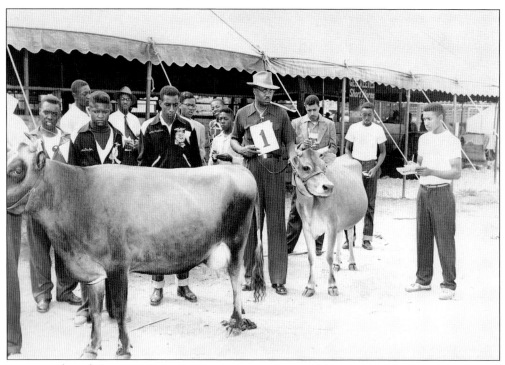

Dairy cattle judging was a competitive activity sponsored by local NFA chapters and state associations and afforded members the opportunity to appraise animals for specific production qualities. NFA members in this image judge two animals at a dairy competition around the 1950s.

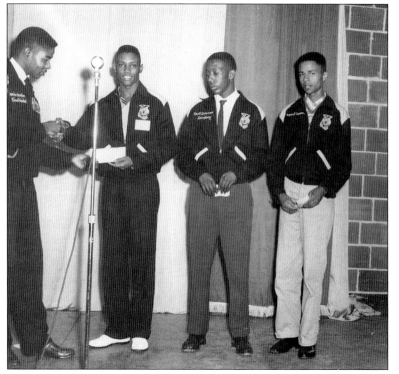

Marvin Rountree, the 1956–1957 national NFA president, presents an award to an NFA member at the 1957 national convention, held from September 30 to October 4, 1957. The presentation of awards was a major component of national conventions, with nominations for the awards coming from state-level NFA associations.

James McKoy receives a $15 check as the second-place state winner in the farm electrification contest. Given the emergence of electricity in rural America during the years of the NFA, the farm electrification contest was created to allow members to become familiar with the necessary skills in the use of electricity on the farm. The award was donated by the National FFA Foundation. McKoy held the modern farmer degree and farmed in partnership with his father.

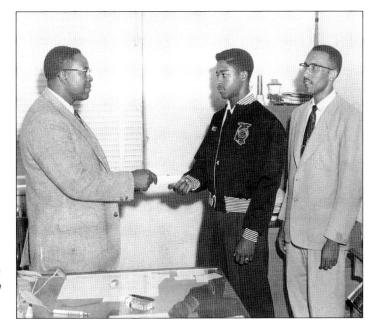

Public speaking was a major contest program for the New Farmers of America organization, designed to develop the oratorical skills of its members as future agricultural leaders. The speech topics could include a variety of subjects concerning the agricultural industry, farming, and issues impacting rural America. Shown here are the participants from the 1953 North Carolina state-level public speaking contest.

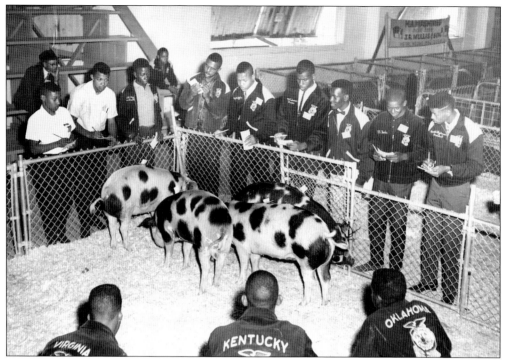

Having the ability to properly evaluate swine according to market standards was imperative for NFA members in producing high-quality animals. In this photograph, NFA members from the Virginia, Kentucky, and Oklahoma Associations, along with members from other states, judge a group of market hogs at a national convention. (Courtesy of IUPUI.)

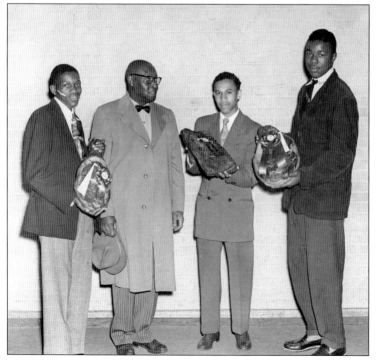

Ham, bacon, and egg shows were largely started to help farmers improve egg and meat production quality and preservation techniques. These shows have deep roots at 1890 land grant institutions. Here, the 1953 West Virginia state ham, bacon, and egg reserve and grand champions are shown.

Supervised farming projects allowed NFA members to gain invaluable experience with a variety of agricultural enterprises outside of traditional classroom instruction. This photograph from 1960 features the East Union NFA supervised farming project and its members who worked on it.

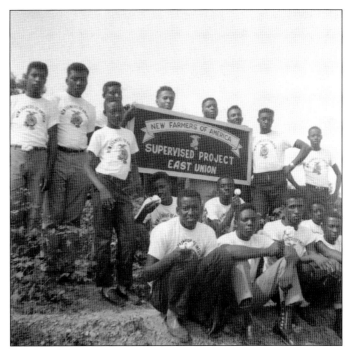

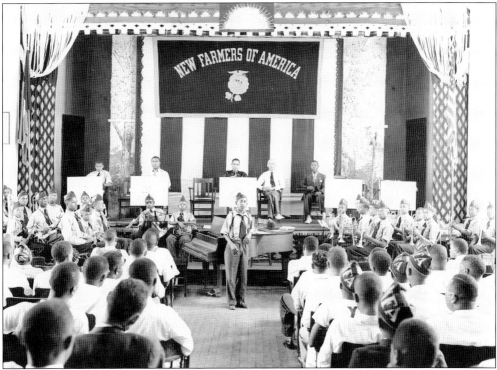

The NFA Band of Laurinburg, North Carolina, was the first official band to take part at a national convention, in Savannah, Georgia, in August 1938. The band played songs such as the "The Star-Spangled Banner," "Lift Every Voice and Sing," "The NFA Creed Song," and a variety of jazz tunes for convention entertainment.

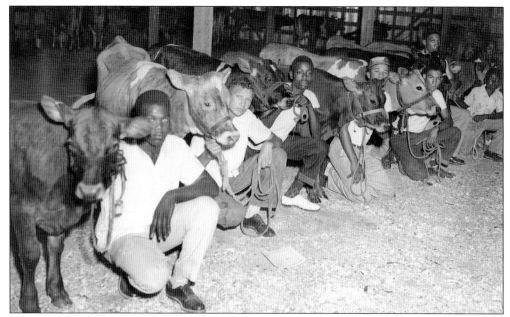

Community involvement in the secondary vocational agriculture program was a key aspect of New Farmers of America programming. Here, NFA members from four counties meet at T.S. Cooper High School in Gates County, North Carolina, to conduct the Roanoke-Chowan Dairy Cattle Show. The event was attended by school officials, extension professionals, and other community leaders.

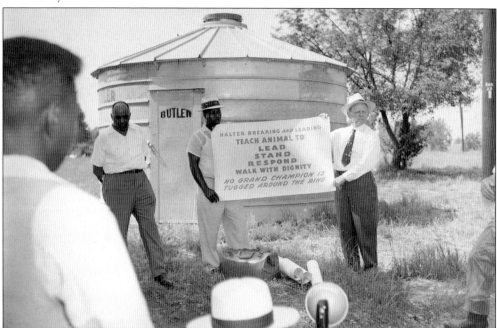

To help NFA advisors to properly train their students to show livestock, S.B. Simmons (left, facing camera), assistant supervisor for agricultural education in Black schools in North Carolina from 1930 to 1957, sponsored a workshop on the proper techniques for halter breaking and leading show animals.

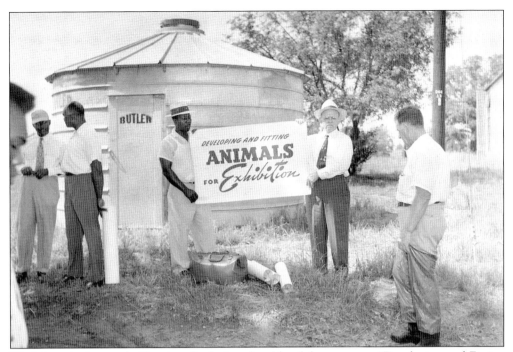

Workshop facilitators hold a sign displaying the title of the program: "Developing and Fitting Animals for Exhibition." The workshop provided NFA advisors with the requisite skills needed to properly train their respective members for showing livestock.

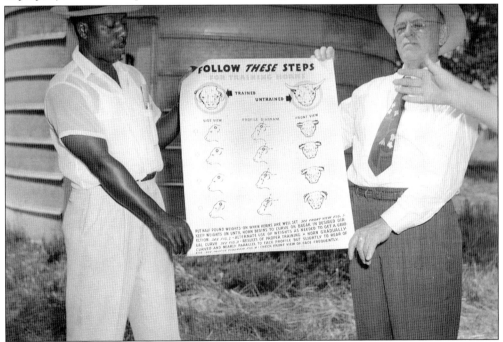

As a component of the workshop on developing and fitting animals for exhibition, NFA advisors received information on how to train cattle horns. The chart shown in this photograph provides different views of how to train horns and instructions on how to use weights to do so effectively.

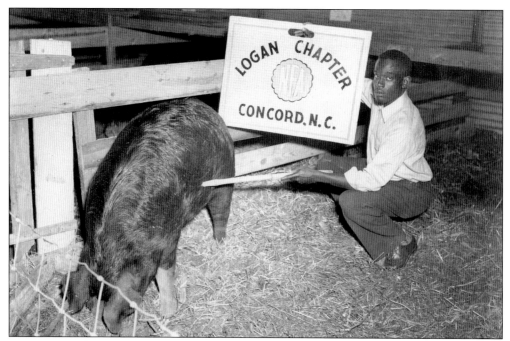

An NFA member and member of the Logan Boar Association from Concord, North Carolina, shows his boar as a part of his swine project. The Logan Boar Association, which was founded in 1941, was comprised entirely of NFA members.

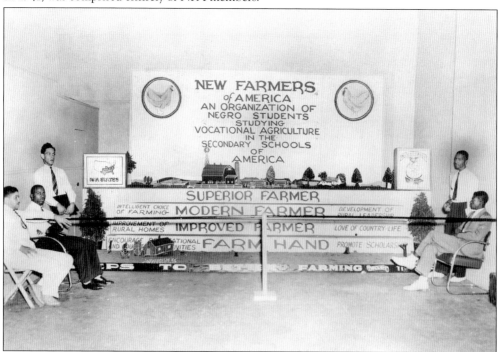

An NFA exhibit is on display at the Seventh World's Poultry Congress in Cleveland, Ohio, in 1942. The exhibit specifically details the levels of active membership—farm hand, improved farmer, modern farmer, and superior farmer—in addition to the specific purposes of the organization.

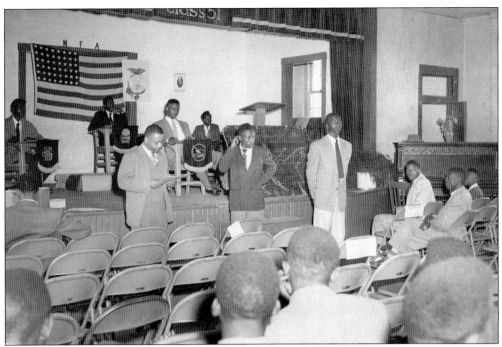

W.T. Johnson (left, reading), assistant supervisor of agricultural education for Black schools in North Carolina and state NFA executive secretary, announces the close score for the first-place winners of the NFA public speaking contest for the W.B. Jamieson Group Federation. Standing next to Johnson is the first-place winner, Robert Flynn (center), of the Beaufort County High School NFA chapter, and the second-place winner, Ira McCloud (right) of the Belhaven NFA chapter.

One of the major events of the National NFA Week, which took place during the week of Booker T. Washington's birthday, April 5, was the crowning of Miss NFA, also known as the NFA Sweetheart or Miss NFA Sweetheart. At the final NFA convention in October 1965 in Atlanta, Joyce Lyons of Britton High School in Rayville, Louisiana, was selected unanimously as the last NFA Sweetheart by the convention delegates.

NATIONAL NEW FARMERS OF AMERICA SWEETHEART

Joyce Lyons
Britton High School
Rayville, Louisiana

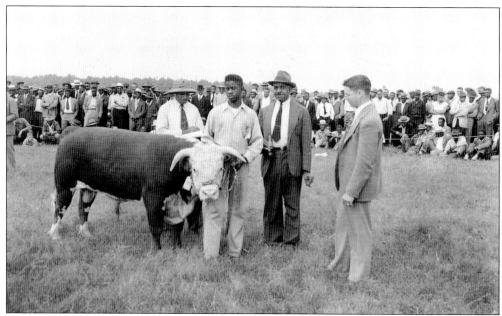

Sears, Roebuck and Company contributed greatly to improving cattle breeding throughout the states represented by the NFA through its bull program, which provided NFA members with high-quality Hereford bulls for breeding and showing. Shown here, a NFA member presents a champion NFA Sears Hereford bull at a cattle show at North Carolina A&T State University in 1951.

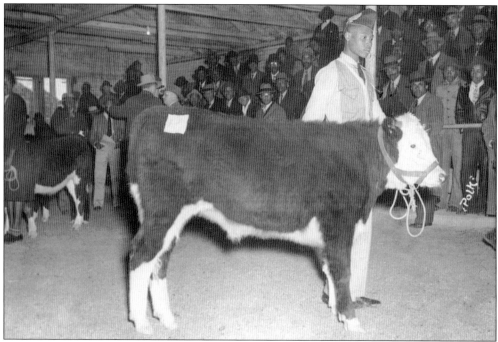

NFA member Willie Sheperd shows his winning steer at the fifth annual Farm and Home Week at Tuskegee Institute in 1940. The six-month-old steer brought Shepherd $76.50. This was part of his supervised farming project.

The quartet contest was one of the most competitive and anticipated contests at the national NFA conventions. The purpose of the contest was to develop a greater appreciation for good music, including spirituals. The 1951 NFA National Quartet Contest winners were from North Carolina. From left to right are Warren Murphy, Carl Ellis, George Stevenson, and James Edge.

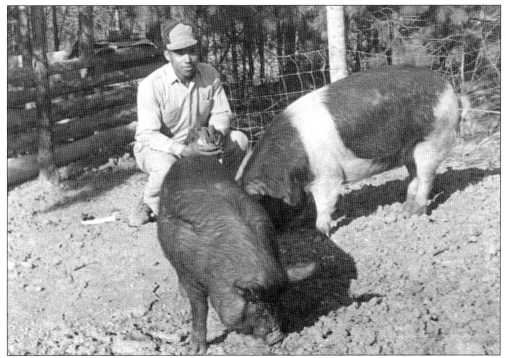

Proficiency in livestock production was a major goal for many NFA members. In 1953, R. Moore, one of the most successful young NFA swine growers, looks over two of his best animals.

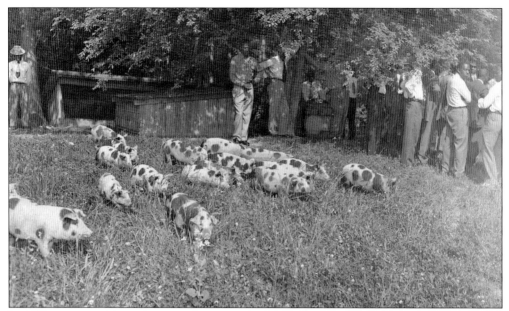

In 1953, vocational agriculture teachers visit the McKinley farm for the purpose of purchasing gilts. McKinley, a former NFA member, was regarded as the largest African American seller of breeding animals in North Carolina at that time.

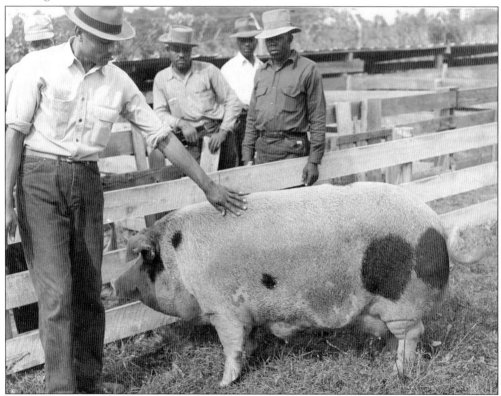

A sow is shown at the 1953 Ahoskie NFA Swine Show. This was one of the largest annual swine shows for Black farmers in North Carolina.

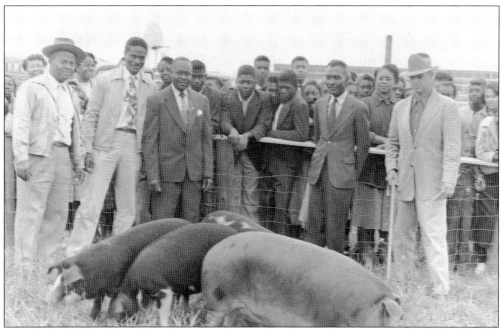

In 1953, the Phillips High School vocational agricultural education department held a local swine show to determine which animals would be shown at the Ahoskie NFA Swine Show.

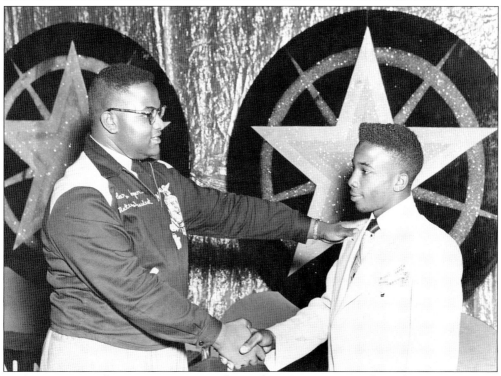

At the 1953 national NFA convention in Atlanta, the 1952–1953 national president Curtis Cooper of Georgia presents an award during a general session. Each of the NFA's national officers were assigned to present awards during each of the convention's general sessions.

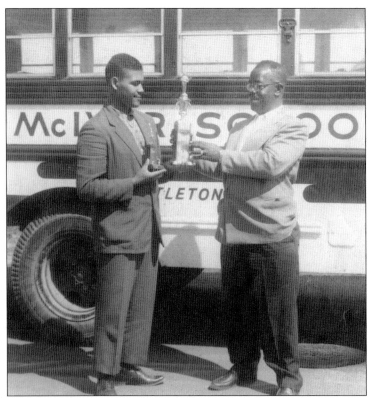

An NFA member at the McIver School in Littleton, North Carolina, receives two awards from his vocational agricultural education teacher. Member recognition through awards was a centerpiece of the NFA plan of work.

Two NFA members display their blue-ribbon-winning heifers at the 1953 cattle show at North Carolina A&T State University. Each award-winning heifer also received a cash prize from that year's show sponsor.

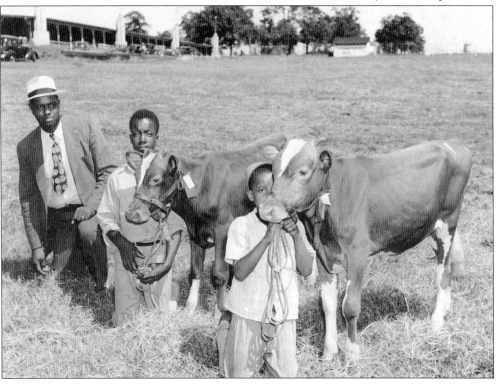

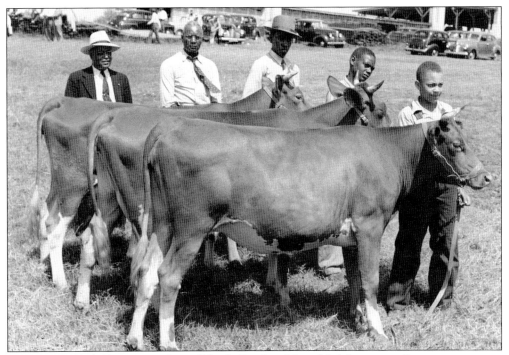

George Cox (far left), vice president of North Carolina Mutual Life Insurance Company, a sponsor of the NFA cattle shows, checks with county agent Ford (second from left) while NFA members show three of the best animals displayed in 1946.

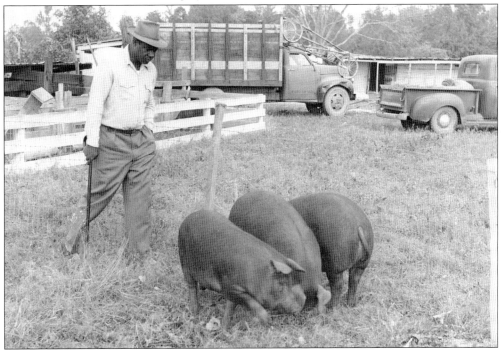

Three of the best animals shown at the 1953 Ahoskie NFA Swine Show are being herded together in preparation for the show's final round.

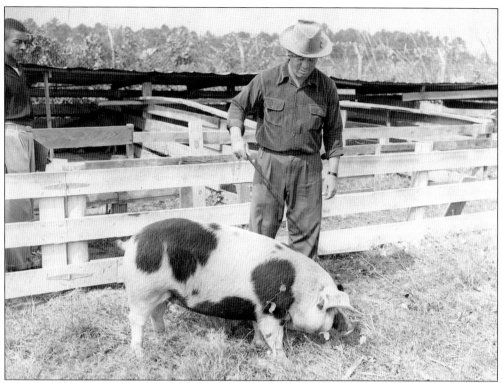

In this photograph, a grand champion animal is shown at the 1953 Ahoskie NFA Swine Show. With a grand champion came prize money and a blue ribbon.

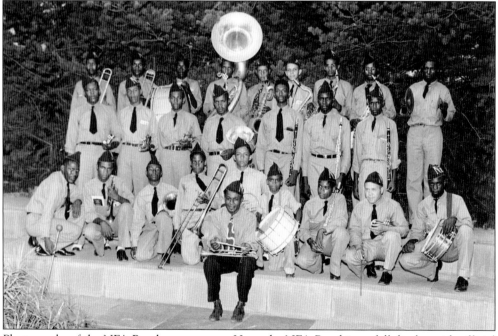

Photographs of the NFA Band are very rare. Here, the NFA Band is on full display with official NFA Band caps at a national convention. Membership in the band was highly selective.

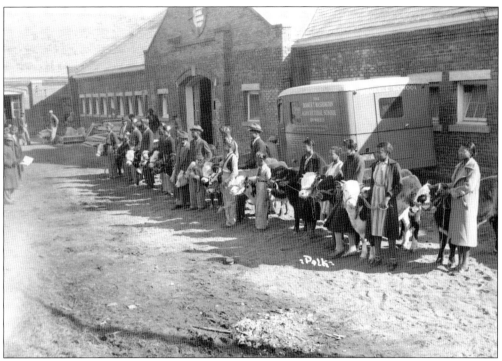

New Farmers of America and 4-H Club entries line up to go into the ring to have their animals judged in competition. This was the first club contest sponsored in Alabama. While the animals lacked finish, the entries were overall a fine beginning. This took place during the fifth annual Farm and Home Week at Tuskegee Institute in 1940.

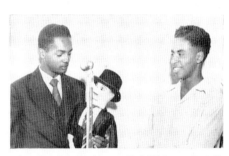

Appropriate rural entertainment is encouraged in the N. F. A. program of work. The N. F. A. "Charlie McCarthy" of the Warren Chapter provides entertainment for many church and school groups in his home and nearby counties.

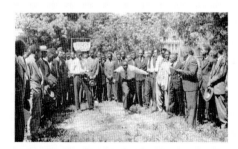

"All work and no play makes Jack a dull boy" is always solved in the chapter program of work. The state championship horse shoe game as seen here has the attention of the contestants as well as the rooters on the side line. N. F. A. sponsors other inexpensive but helpful games like checkers and darts which have proven popular with the boys.

—[6]—

In the top picture in 1947 is the NFA's version of Charlie McCarthy from the Warren Chapter, who provided entertainment for school and church groups in the community and surrounding counties. At bottom, the always highly competitive state-level NFA horseshoe game draws many participants and onlookers.

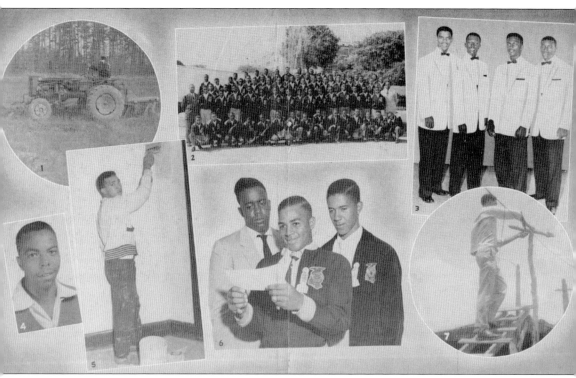

Contests were very important to the programming of the NFA. These photographs show the national contest winners from 1956. From left to right are (top row) Thomas Buster of Nathalie, Virginia, the National Soil and Water Management Award winner, on a tractor; the first National NFA Chorus at Municipal Auditorium; and the first-place quartet winners from Huntsville, Texas—Joe Teamer, Tommie Young, Paul Jones, and Anthony Branch; (bottom row) the national winner for farmer mechanics, Odester Carter of Quincey, Florida; George M. Carter of Emporia, Virginia, the national winner for farm and home improvement, completing a painting job; Dairy Farming Award winners Stanley Brumfield (Louisiana), Joe L. Arrington (Virginia), and Edward M. Saulsby (Florida); and Robert L. Griffin of Marlin, Texas, the national winner for farm electrification, doing electrical repairs on his family's farm.

Five

THE COTTON BOLL
AND CAMPING

One major aspect of the programming for the organization of the "Cotton Boll" was the camping program. As a result of the Jim Crow segregationist laws enacted following Reconstruction in 1877 and the *Plessy v. Ferguson* decision by the US Supreme Court in 1896 establishing the "separate but equal" doctrine, opportunities for African American youth in the rural South were extremely limited. In order to provide such an opportunity for Black youth, S.B. Simmons (agricultural teacher educator, North Carolina A&T State University; state NFA advisor, 1935–1957; national executive secretary, 1935–1941; and executive treasurer, 1935–1955) had a vision to establish a camping program through the NFA that would emphasize citizenship, leadership, moral values, and sportsmanship. Not all states had a camping program, but two in particular that will be highlighted in this chapter are the S.B. Simmons Camp at Hammocks Beach in Swansboro, North Carolina, and Camp John Hope in Fort Valley, Georgia. The S.B. Simmons Camp, named in honor of the late S.B. Simmons, was dedicated on June 20, 1958. Construction on Camp John Hope began on July 26, 1937, with the camping program beginning the following year in 1938. Hundreds of youth participated in the camping programs during the years of the NFA.

The camps offered activities such as fishing, crabbing, track and field, boating, horseshoes, conservation, group games, arts and crafts, overnight hikes, camp cookouts, swimming, leadership activities, campfire programs, movies, and many others. These camps are some of the most memorable legacies of the NFA.

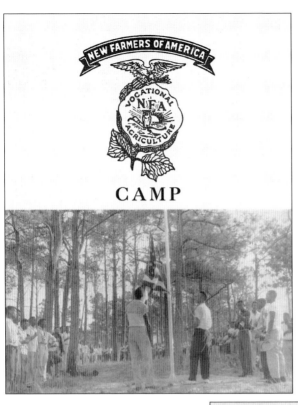

CAMP

Before it became known as the S.B. Simmons Camp in North Carolina, it was simply called the New Farmers of America Camp when it was established in 1953. The NFA Camp in North Carolina was unique in that it was located on beachfront property and available exclusively for African American students, a rarity for the time. The camp was at Hammocks Beach near Swansboro in Onslow County. Participants were provided with opportunities for leadership training, recreation, and instruction in natural resources conservation. The camp was under the management of the North Carolina Association at North Carolina A&T State University.

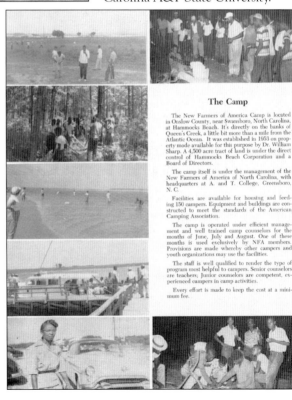

The Camp

The New Farmers of America Camp is located in Onslow County, near Swansboro, North Carolina, at Hammocks Beach. It's directly on the banks of Queen's Creek, a little bit more than a mile from the Atlantic Ocean. It was established in 1953 on property made available for this purpose by Dr. William Sharp. A 4,500 acre tract of land is under the direct control of Hammocks Beach Corporation and a Board of Directors.

The camp itself is under the management of the New Farmers of America of North Carolina, with headquarters at A. and T. College, Greensboro, N. C.

Facilities are available for housing and feeding 150 campers. Equipment and buildings are constructed to meet the standards of the American Camping Association.

The camp is operated under efficient management and well trained camp counselors for the months of June, July and August. One of these months is used exclusively by NFA members. Provisions are made whereby other campers and youth organizations may use the facilities.

The staff is well qualified to render the type of program most helpful to campers. Senior counselors are teachers; Junior counselors are competent, experienced campers in camp activities.

Every effort is made to keep the cost at a minimum fee.

The NFA Camp at Hammocks Beach in Swansboro served as the summer camp for the North Carolina Association. It was later named after S.B. Simmons, who served as the national organization's first executive secretary-treasurer from 1935 to 1941 and executive treasurer from 1941 to 1955. The camp's dedication ceremony took place on June 20, 1958. The camp provided a variety of activities such as fishing, crabbing, horseshoes, art and crafts, overnight hikes, boating, baseball, group games, conservation activities, and swimming.

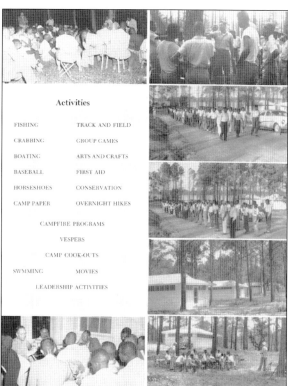

Activities

FISHING	TRACK AND FIELD
CRABBING	GROUP GAMES
BOATING	ARTS AND CRAFTS
BASEBALL	FIRST AID
HORSESHOES	CONSERVATION
CAMP PAPER	OVERNIGHT HIKES

CAMPFIRE PROGRAMS

VESPERS

CAMP COOK-OUTS

SWIMMING MOVIES

LEADERSHIP ACTIVITIES

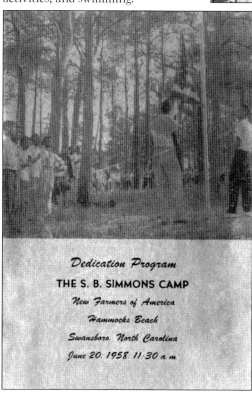

Dedication Program

THE S. B. SIMMONS CAMP

New Farmers of America

Hammocks Beach

Swansboro, North Carolina

June 20, 1958, 11:30 a.m.

CAMP JOHN HOPE

Route 3

Fort Valley, Georgia

GENERAL INFORMATION

I. Location.—The Camp site is located on 222 acres of land near St. Louis Community, seven miles southwest of Fort Valley in Macon County, Georgia, about the center of the state, easily accessible to all sections.

II. Purposes.—

1. To advance the educational, social, physical and moral welfare of Negro youths in Georgia through the establishment and maintenance of camping and recreational center, and

2. Such center shall be available as a general meeting place for educational and religious conferences as well as for athletic events.

III. Description

About one-half of the 222 acres of land is covered with beautiful forest and woods, tall pines, heavy shade oaks, dogwoods, maples and gum trees. Approximately one hundred acres of the tract is open level land, furnishing adequate athletic facilities can accommodate 275 persons. A 2600 gallon water tank, a deep well furnishing artesian water, two athletic fields for baseball and softball, two volley ball courts, one basketball court, a horseshoe ring, a croquet court and two tennis courts provide health and recreation. In addition, there is a lake covering approximately twenty-five acres of ground which furnishes opportunity for swimming, boating and fishing.

——o——

MANAGEMENT

The Georgia State Coordinating committee
of the
State Department of Education
for
Camp John Hope

Camp John Hope was established on 226 acres in the northeast corner of Macon County, Georgia, overlooking Lake Lassiter. The camp was named after Dr. John Hope of Augusta, Georgia, president of Atlanta University during the early 1930s. Dr. Hope possessed a particular interest for underprivileged youth and early on recognized the need to establish a continuing education and recreation place for young African American men. He a had special interest in organizations for young Black men. The camp provided a variety of activities for participants such as horseshoes, fishing, croquet, tennis, volleyball, softball, basketball, swimming, and boating. Camp John Hope provided the camping program for the Georgia Association, which was headquartered at Fort Valley State University.

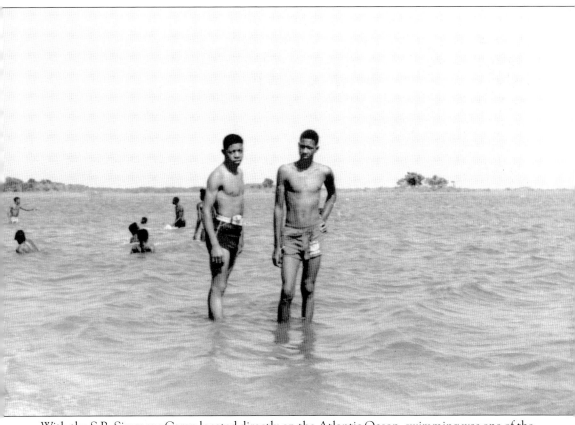

With the S.B. Simmons Camp located directly on the Atlantic Ocean, swimming was one of the most popular activities for both students and advisors. Swimming provided camp participants with an opportunity for physical fitness. One of the stated purposes of the NFA was to provide and encourage the development of organized rural recreational activities and to create and nurture a love of country life. It also emphasized leadership development, sportsmanship, and teamwork through camping activities. The camp provided a unique venue that supported the NFA's goals. Consisting of waterways for boating and swimming, ocean access, and a plethora of forestry resources for instruction in natural resources, the camp was an ideal location for youth leadership programming.

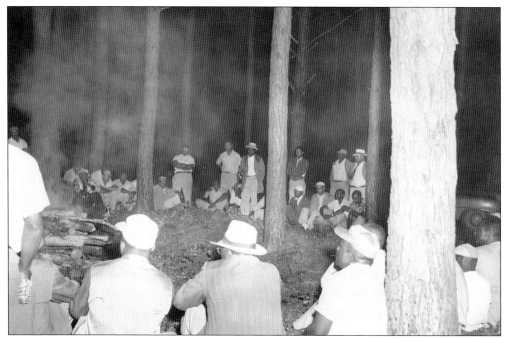

In order to train counselors in how to effectively conduct the camping program, the NFA camps provided a weeklong workshop where they gained a full camping experience, which included campfire activities at night, a central activity of the regular camping program. Counselors included both vocational agricultural education teachers and other professionals. Counselors lived in the same Army tents as campers, which provided the primary housing for counselors during the camp's first few years before cabins were built. During the workshop, the counselors had the opportunity for recreational activities such as fly-fishing, deep-sea fishing, and boating.

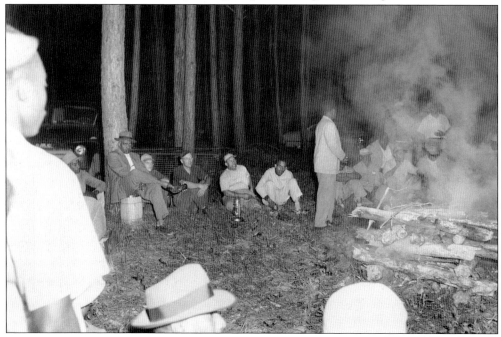

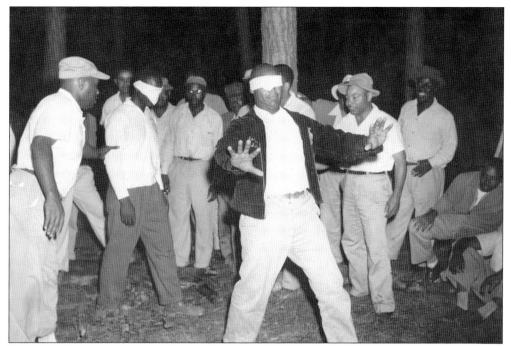

The NFA camps included a variety of fun activities for participants. In this photograph, two campers participate in a blindfold activity during the nightly campfire session.

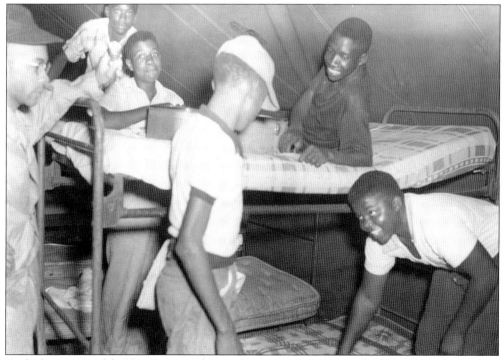

At the beginning of the New Farmers of America camping program in North Carolina, the campers lived in old Army tents. Campers from various NFA chapters were divided up and placed into tents to allow students from different parts of the state to meet each other and establish relationships.

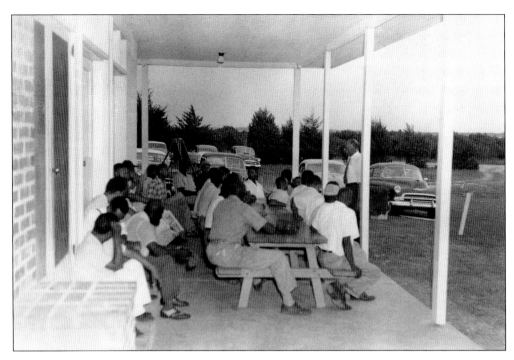

The North Carolina Teachers Association Building served as the dining facility for the S.B. Simmons Camp. The association served as the statewide organization for African American educators for nearly a century after Reconstruction, ending with the desegregation of the state's public schools in the 1960s. Above, the building provided a meeting place for camp leaders and NFA advisors, such as this meeting conducted by S.B. Simmons (standing, far right). Below, a group of NFA advisors, some holding fishing rods, pose in front of the building.

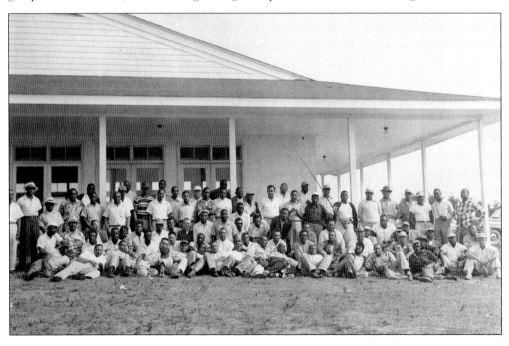

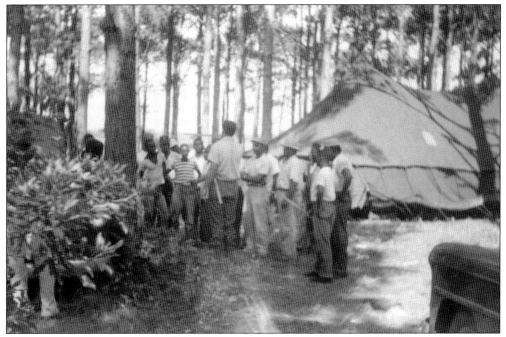

The S.B. Simmons Camp provided campers with instruction in natural resources conservation and forestry. In November 1954, an official from the North Carolina Forest Service provided a workshop on conservation techniques.

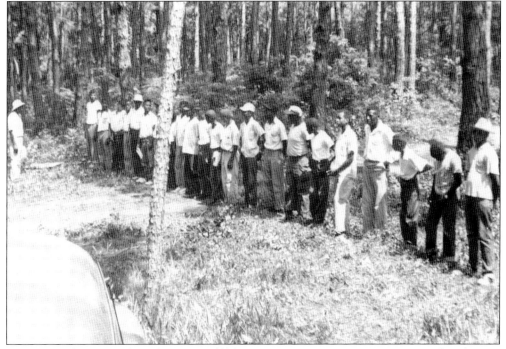

Subjects such as tree identification, wildlife management, tree measurement, soil and water conservation, and wildfire prevention were emphasized at the S.B. Simmons Camp. Here, camp participants prepare for their day of conservation instruction.

Deep-sea fishing was a major activity at the S.B. Simmons Camp. The boat used at the camp was the *Sonny Boy* and provided camp attendees and NFA advisors with the ability to explore and fish far out into the ocean.

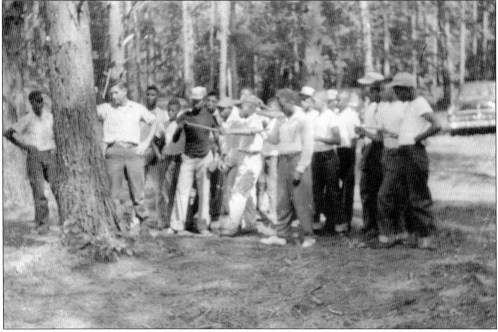

The North Carolina Forest Service was a major partner in the S.B. Simmons Camp program. Through this partnership, students learned various skills such as how to measure trees and natural resources conservation.

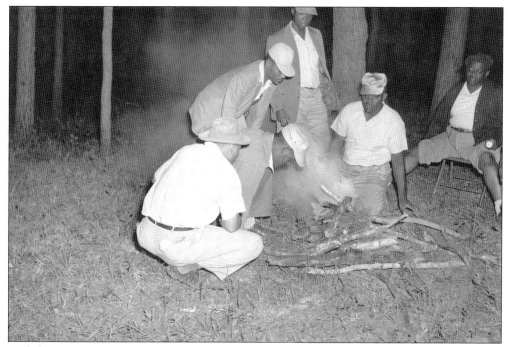

Nightly campfire activities were a major part of the S.B. Simmons Camp program and a place for much fun and camaraderie. The campfire each evening was started by the camp counselors and NFA advisors.

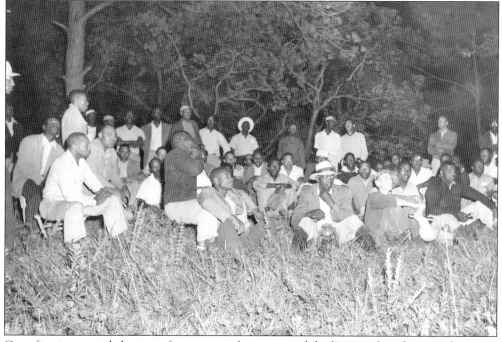

Campfire time provided a venue for a variety of activities such as barbeques, charades, campfire songs, toasting marshmallows, and storytelling. In this photograph, camp participants and counselors participate in a campfire, with some sitting in the front holding lanterns and flashlights.

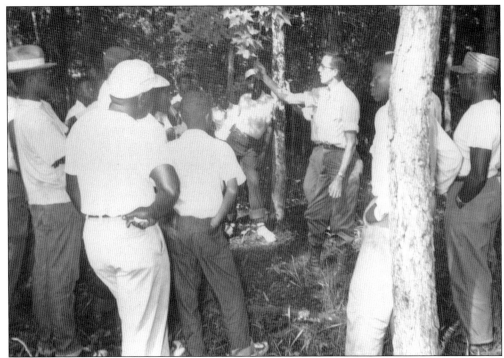

Tree identification is a skill that was taught in natural resources conservation. Here, an official from the North Carolina Forest Service provides instruction to campers.

In the summer of 1954, campers in North Carolina have a discussion in their tent. Old Army tents were used for housing before permanent cabins were built at the camp in 1956.

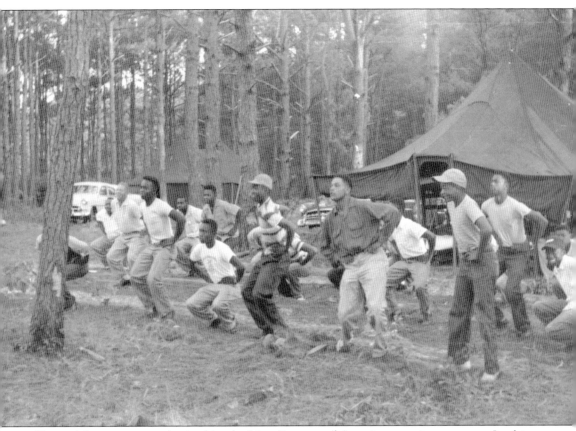

Physical fitness was emphasized in the New Farmers of America camping program. In this photograph from 1954, students exercise in front of their tents to begin the day.

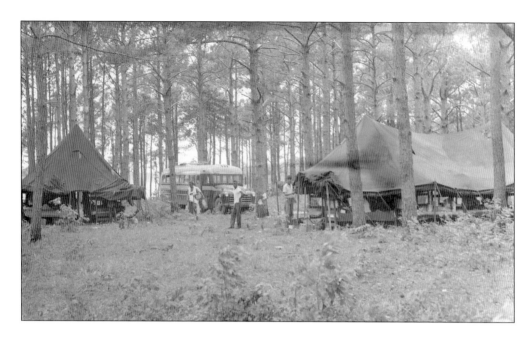

When the NFA Camp in North Carolina was established in 1953, it did not have any buildings such as cabins or other permanent structures. In order to house campers, old Army tents were acquired, which in later years were replaced by cabins. The camp's objectives were to instill in all campers leadership, citizenship, moral values, sportsmanship, and educational instruction in specific topics, such as natural resources conservation. Upon arriving, campers were placed in various groups in order for them to meet members from other parts of the state. Both photographs were taken in 1954.

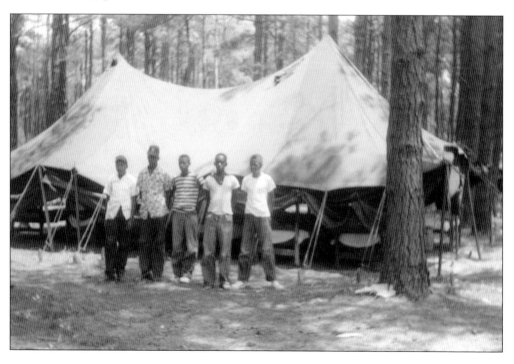

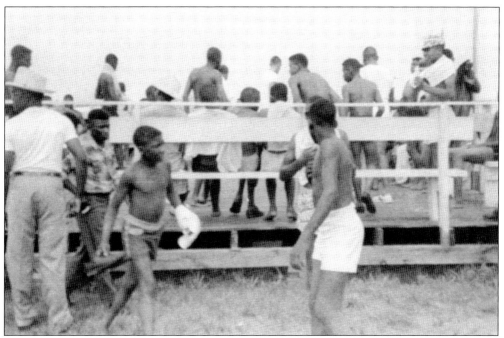

The S.B. Simmons Camp in Swansboro provided NFA members with a variety of recreational activities. The beachfront camp provided members with prime opportunities for swimming and other water activities, as pictured here in 1954.

The pier at the S.B. Simmons Camp was a place of much activity. The pier did not exist in the first few years of the camp, but once it was built in the late 1950s, it provided campers, counselors, and NFA advisors a place from which to fish, enjoy the ocean, and dock smaller boats for fishing.

Campfire Activities

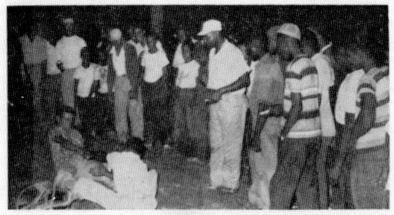

The S. B. Simmons New Farmers of America Camp, located at Hammocks Beach, near Swansboro, N. C., provides recreation, education and leadership opportunities for youth

Campfire activities were a nightly activity at the S.B. Simmons Camp. Through the campfire activities, camaraderie was developed and memories were made. In this image, young men participate in an activity.

Recreation Basketball

The S. B. Simmons Memorial Camp, located at Hammocks Beach, near Swansboro, N. C., provides recreation, education and leadership opportunities for youth

Basketball provided campers at the S.B. Simmons Camp with an activity that emphasized teamwork and competition, and was one of the most popular camp activities.

Recreational Activities

The S. B. Simmons New Farmers of America Camp, located at Hammocks Beach, near Swansboro, N. C., provides recreation, education and leadership opportunities for youth

Croquet was one of the recreational activities at the S.B. Simmons Camp. This activity promoted much competition between campers.

Forestry—Measuring Trees

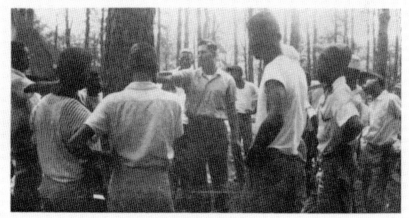

The S. B. Simmons New Farmers of America Camp, located at Hammocks Beach, near Swansboro, N. C., provides recreation, education and leadership opportunities for youth

Agriscience and natural resources were important components of the S.B. Simmons Camp experience. In this photograph, campers are provided instruction on the proper way to measure trees during a forestry workshop.

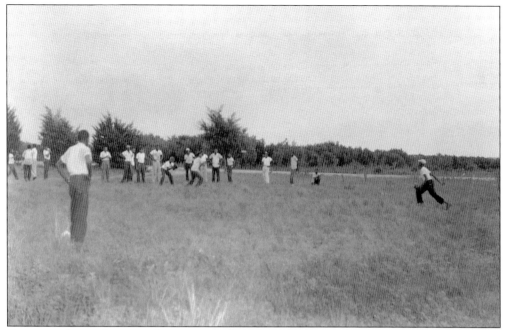

Sportsmanship and teamwork were principles taught during the week of camping. Softball was a highly competitive recreational activity at the S.B. Simmons Camp that emphasized both.

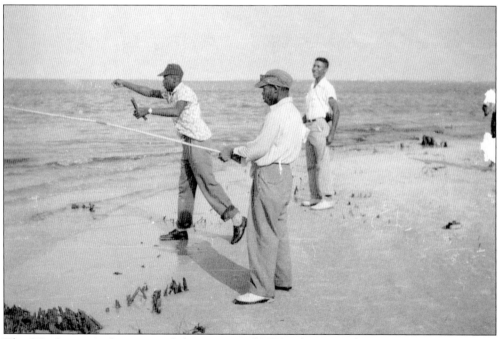

The S.B. Simmons Camp provided campers and NFA advisors with a great venue for fishing. NFA advisors found much enjoyment in fishing at the camp.

In 1954, campers in North Carolina stand in the rain as they participate in an activity and receive instructions.

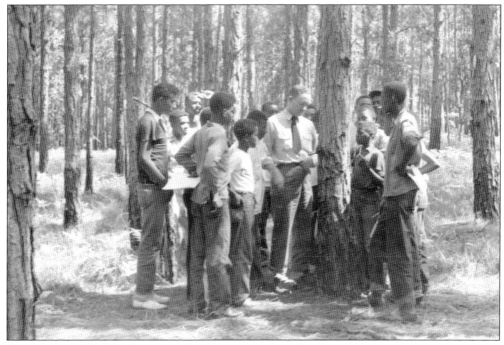

During the 1954 S.B. Simmons Camp session, attendees learned about the importance of forestry to environmental conservation during a workshop conducted by a North Carolina Forest Service official.

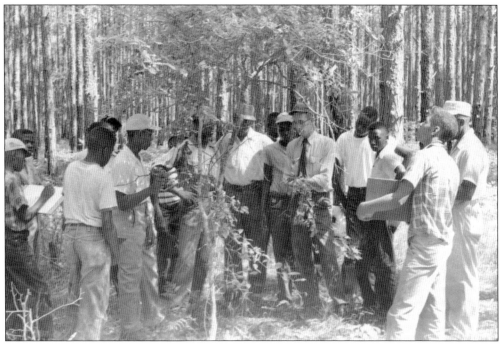

Here, participants at the S.B. Simmons Camp are taught how to identify trees through an analysis of leaves at the 1954 camping session.

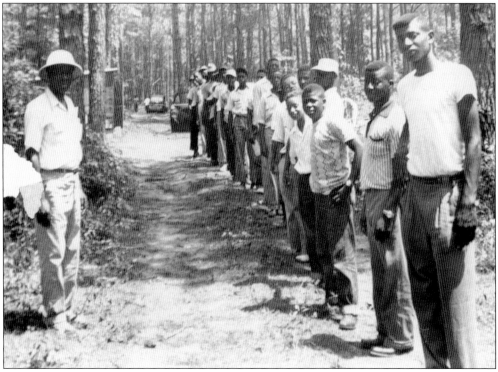

In this photograph from the 1954 camping season at the S.B. Simmons Camp, a group of campers and their advisor prepare for the day's activities.

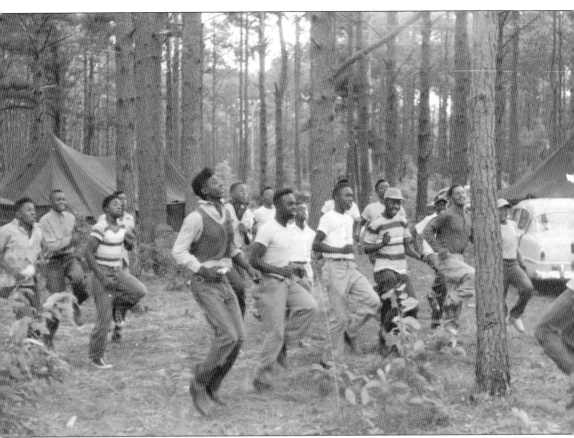

One of the purposes of the NFA, as indicated in the *NFA Guide*, was to "provide and encourage the development of organized rural recreational activities." The camp in North Carolina provided an ideal venue for this. S.B. Simmons had envisioned a camp where sportsmanship could be emphasized as a central value. Physical fitness was a major objective of the NFA camp program and was promoted throughout the camp week. In this photograph from 1954, participants exercise in front of their tents.

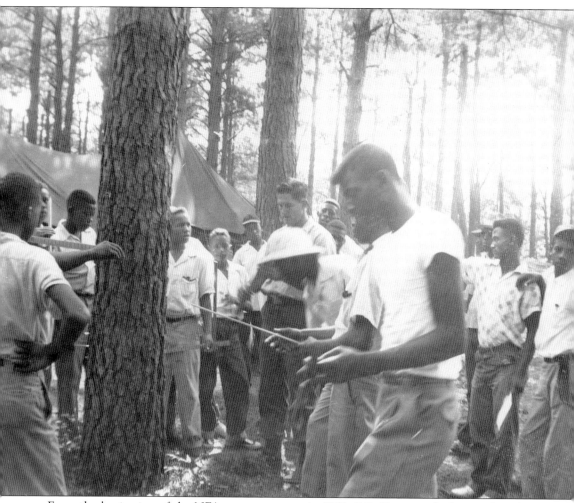

From the beginning of the NFA camp program in 1953, S.B. Simmons had several goals in mind for its operation, which included the development of leadership, moral values, citizenship, and sportsmanship, in addition to scholarship for rural African American youth. At the camp, instruction in the conservation and appreciation of natural resources was emphasized, particularly in relation to forest resources and wildlife. The North Carolina Forest Service was a key partner in the accomplishment of this goal, providing programming on a wide range of subjects for campers. In this photograph, representatives from the North Carolina Forest Service provide campers with instruction on how to accurately measure trees. Conservation was taught at each camping session.

Six

THE DEMISE OF
THE COTTON BOLL

The merger of the NFA with the FFA in 1965—the demise of the New Farmers of America—was precipitated by many factors external to both organizations. The *Plessy v. Ferguson* Supreme Court case of 1896 established the "separate but equal" doctrine that would dominate the very fabric of public education in the South for the next 50 years. In 1954, the Supreme Court ended the "separate but equal" doctrine under the *Brown v. Board of Education of Topeka* case. The Brown decision led to the integration of schools throughout the United States. The most noted was the integration of Little Rock Central High School in Arkansas. Nine Black students were selected to attend Little Rock Central and were faced with a very hostile environment. This crisis in Little Rock had a profound impact on America and the rest of the world. It provided proof of the lengths to which some southerners would go to prevent integration.

The Civil Rights Act was preceded by a lengthy debate that was fought by southern congressmen, but a change in society was inevitable. Change is what happened with the reception of this bill, signed into law by Pres. Lyndon B. Johnson on July 2, 1964. It essentially provided a tool that permitted the Department of Justice to file suit for the overall achievement of desegregation in the public schools. The Civil Rights Act was pushed by the Department of Health, Education, and Welfare, and the department played an important role in the merging of the FFA and the NFA. The FFA national board of directors and the US commissioner of education approved that membership in FFA effective July 1, 1965, was open to all agriculture students regardless of race, color, or national origin. The NFA held its final national convention during the first week of October 1965. The next week at the national FFA convention, a ceremony was held to symbolize the merger of the NFA and the FFA.

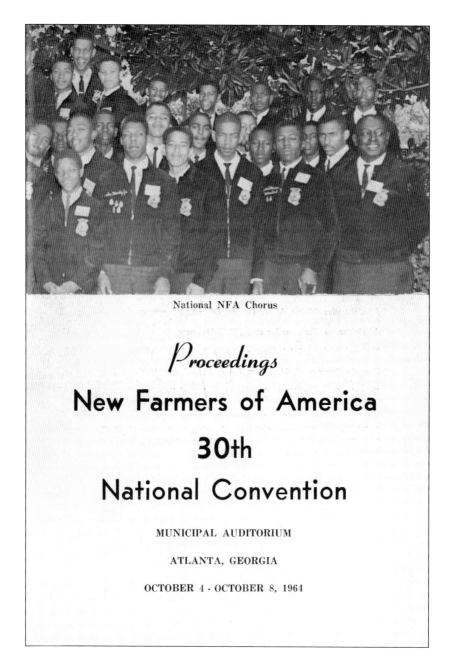

National NFA Chorus

Proceedings

New Farmers of America

30th

National Convention

MUNICIPAL AUDITORIUM

ATLANTA, GEORGIA

OCTOBER 4 - OCTOBER 8, 1964

The 1964 national NFA convention, which took place October 4–8, marked the 30th national convention and the next-to-last one for the organization. At this convention, rumors abounded, and discussions took place regarding the inevitable merger with the Future Farmers of America because of the civil rights movement impacting the United States during that time. Delegates were present from 14 state associations. Approximately 1,000 individuals attended the convention. The national officer team for the 1963–1964 year consisted of representatives from Tennessee, Virginia, Georgia, Louisiana, South Carolina, Florida, and Texas. Mayor Ivan Allen of Atlanta was introduced as the distinguished speaker and congratulated the organization on its accomplishments and future direction. The 1964–1965 national officer team was installed, which would officially be the last national officer installation ceremony for the NFA.

NEW FARMERS OF AMERICA

31st National Convention

FINAL

October 5 - October 8, 1965

MUNICIPAL AUDITORIUM

Atlanta, Georgia

Heeding the request of the national NFA adult officers, the US Office of Education approved a 31st and final national convention of the NFA. This request was made for the purpose of providing an opportunity to end, in appropriate style, the work of 30 years. The convention took place October 5–October 8, 1965, in Atlanta's Municipal Auditorium. This was exactly one week before the 1965 national FFA convention, when the official merging ceremonies would take place. During the convention, final contest programs and award ceremonies took place. Remarks were provided by many distinguished guests such as Mayor Allen; H.N. Hunnsicker, chief of the Agricultural Education Branch of the US Office of Education; and various FFA Foundation donor representatives. One highlight of the convention was the address delivered by Dr. Lewis C. Dowdy, president of North Carolina A&T State University, who was a former NFA member in South Carolina. He emphasized that the word "Final" on the program should be thought of as an "opportunity for wider service, final for today but new opportunities on tomorrow."

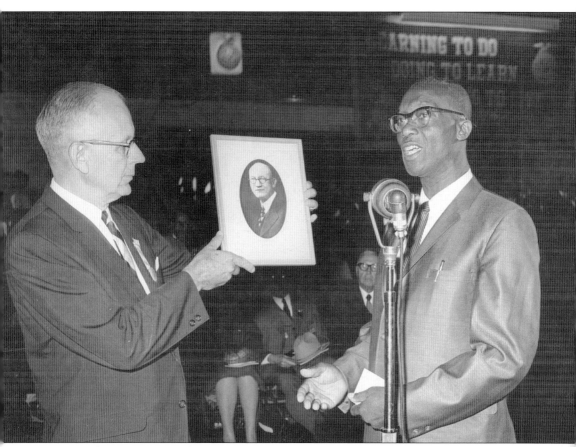

On October 13, 1965, in Kansas City, Missouri, at the national FFA convention, a ceremony was held to symbolize the joining together of the NFA and the FFA. In this photograph, G.W. Conoly, retiring national NFA advisor, presents a picture of Dr. H.O. Sargent for the FFA archives to Dr. A.W. Tenney, FFA national advisor. Traditionally, it has been thought that the merger of the FFA and NFA occurred at the 1965 national FFA convention, but that was not the case. Even though a grand merging ceremony took place at the 1965 national FFA convention, during which time the NFA Chorus performed with the FFA Chorus, the actual date of the merger was July 1, 1965. This was agreed upon by the NFA, FFA, and the US Office of Education. After July 1, 1965, the NFA no longer officially existed.

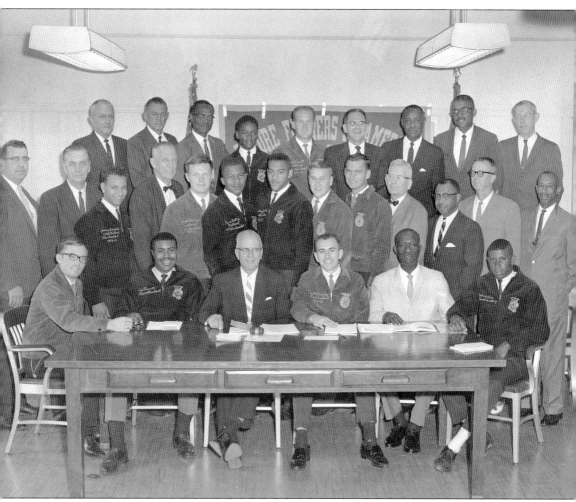

On May 17, 1954, the US Supreme Court made a monumental decision with the *Brown v. Board of Education of Topeka* case. It ruled that "separate but equal" public schools were unconstitutional and in essence violated the equal protection clause of the 14th Amendment. This case served as a major catalyst for the 20th-century civil rights movement and provided inspiration for the total transformation and reform of the educational system, challenging and eliminating segregationist systems. Secondary vocational agricultural education, and more specifically, the NFA and FFA, were impacted by this as public school entities were required to consolidate. A joint meeting of the national student officers and administrative board of the FFA and the NFA was held in Washington, DC, on July 29, 1965, to plan for their national conventions and to complete the official transfer of the NFA into the FFA.

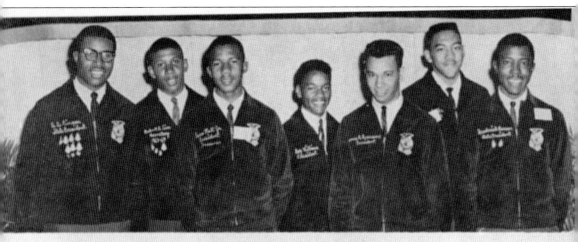

NEW NATIONAL OFFICERS

Left to right: Adolphus Pinson, President; Robert Tice, Secretary; Esco Hall, 1st Vice President; Roy Williams, Treasurer; James Broussard, 2nd Vice President; George Wingfield, Reporter; Frederick Benson, 3rd Vice President.

The 1964–1965 NFA national officer team constituted the last one before the merger with the FFA in 1965. Pictured here are, from left to right, Adolphus Pinson, president; Robert Tice, secretary; Esco Hall, first vice president; Roy Williams, treasurer; James Broussard, second vice president; George Wingfield, reporter; and Frederick Benson, third vice president. They represented Texas, Florida, Georgia, North Carolina, Louisiana, Arkansas, and South Carolina. The last national NFA officer team had many tremendous tasks to accomplish, which included closing out the work of the NFA as an organization but also helping to facilitate an effective merger with the FFA. It was a time of historic changes and activities that would forever impact secondary vocational agricultural education and the development of diverse future agricultural leaders, ones needed for the global agricultural industry.

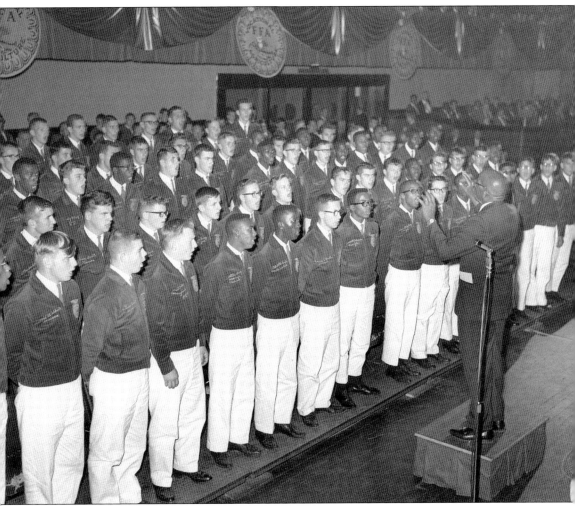

At the 1965 national FFA convention, the 50-voice NFA Chorus, which was comprised of state winning NFA quartets, along with the FFA Chorus, together formed the Merger Chorus and performed in unison during various sessions on the evening of October 12, 1965, and the afternoon and evening of October 13, 1965. The choir was under the direction of I.S. Glover, chorus director and teacher of vocational agriculture in Sylvester, Georgia. The NFA members wore official FFA jackets with the word "Chorus" on the back and FFA ties to symbolize the unification of the organizations. The NFA Chorus and FFA Chorus were seen as groups that could easily be brought together to show cooperation between the organizations as they were being brought together as one unified entity.

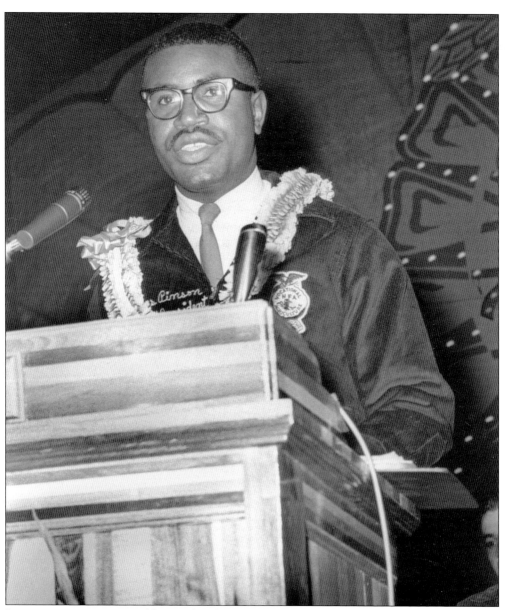

In most mergers, some semblance of each group can usually be found within the final merged body, representing the best parts of the former organizations. This was not the case with the merger of the NFA and FFA. The civil rights movement of 1960 represented a time of tremendous social unrest with traditional social norms being challenged, which was very unsettling to many within the agricultural sector, and more specifically, secondary vocational agricultural education. At the ceremony to facilitate the transfer of NFA symbols and the merging of the organizations on October 13, 1965, Adolphus Pinson, the last national NFA president, provided remarks and officially gave the NFA charter and other records to the FFA to be placed in its archives. With the merger—or more appropriately, the demise—of the NFA, all symbols of African American leadership and participation in secondary vocational agricultural education were eliminated, dramatically impacting and leading to the decline of African American participation and leadership in agricultural education at all levels.

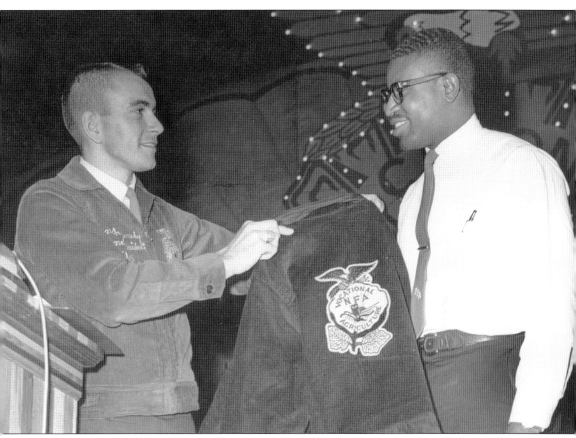

The New Farmers of America was an organization designed to develop future agricultural leaders among rural African American youth enrolled in secondary vocational agricultural education across the state associations that comprised its membership, primarily in the segregated Jim Crow South. The organization, which started in Virginia in 1927 with 18 local chapters, eventually grew into a national organization with over 1,000 chapters and 58,000 members. The final closing act of the NFA was the last national president's exchanging of his NFA jacket for an FFA one. In this picture, Adolphus Pinson, the 1964–1965 national NFA president, gives his jacket to FFA president Kenneth Kennedy, who accepts it for the FFA archives. This officially closed the chapter on a historic organization that for 30 years provided agricultural leadership development for rural Black male youth. The legacy of the NFA is being carried out today by organizations such as Minorities in Agriculture, Natural Resources, and Related Sciences, which has as its primary goals the principles of leadership development, scholarship, diversity, equity, and inclusion within the global agricultural industry.